A–Z

OF

MINEHEAD & DUNSTER

PLACES - PEOPLE - HISTORY

Lynne Cleaver

AMBERLEY

Acknowledgements

With thanks to Somerset Heritage Centre, Jeanne Webb (for her knowledge of the flora of Dunster Beach), Lloyd's Bank Archive, my proofreaders Nigel Cleaver and Richard Boulter, and the staff at Amberley. Every attempt has been made to seek permission for copyright material used in this book. However, if we have inadvertently used copyright material without permission/acknowledgement we apologise and we will make the necessary correction at the first opportunity.

First published 2019

Amberley Publishing
The Hill, Stroud, Gloucestershire, GL5 4EP
www.amberley-books.com

Copyright © Lynne Cleaver, 2019

The right of Lynne Cleaver to be identified as the Author of this work has been asserted in accordance with the Copyrights, Designs and Patents Act 1988.

ISBN 978 1 4456 8736 0 (print)
ISBN 978 1 4456 8737 7 (ebook)

British Library Cataloguing in Publication Data. A catalogue record for this book is available from the British Library.

Typesetting by Aura Technology and Software Services, India. Printed in Great Britain.

Contents

Introduction

Moving to this beautiful area of West Somerset in 2016, my natural curiosity and love of research led me on a voyage of discovery. When the opportunity to produce this book arose I jumped at the chance to share my discoveries with as many people as possible. If you live in either Minehead or Dunster you will be aware, perhaps more than me, of how much there is to each individual place and how much has been missed out in this short volume.

One thing I have found out during my research is how closely the two places have been linked throughout history. At one time Dunster had the main harbour and Minehead was smaller. Changes brought about by the growth of Minehead's harbour resulted in changes for each place. Ownership and control of each place, mostly by the

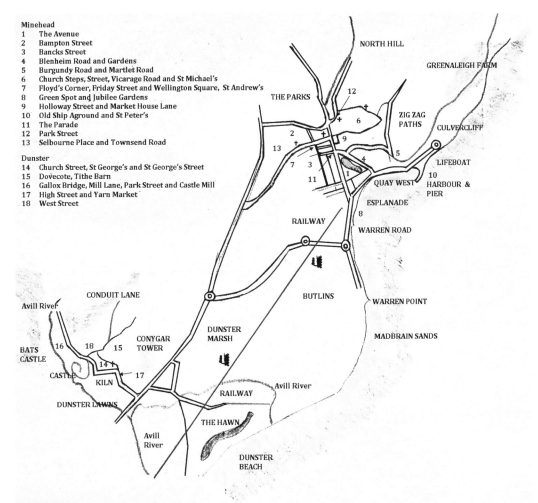

Minehead
1 The Avenue
2 Bampton Street
3 Bancks Street
4 Blenheim Road and Gardens
5 Burgundy Road and Martlet Road
6 Church Steps, Street, Vicarage Road and St Michael's
7 Floyd's Corner, Friday Street and Wellington Square, St Andrew's
8 Green Spot and Jubilee Gardens
9 Holloway Street and Market House Lane
10 Old Ship Aground and St Peter's
11 The Parade
12 Park Street
13 Selbourne Place and Townsend Road

Dunster
14 Church Street, St George's and St George's Street
15 Dovecote, Tithe Barn
16 Gallox Bridge, Mill Lane, Park Street and Castle Mill
17 High Street and Yarn Market
18 West Street

Guide to key streets mentioned in the text.

Luttrell family, will also have affected the development. While Dunster was involved in the cloth trade, Minehead was reliant on the sea and the import and export of goods worldwide. The places we see today, both heavily centred on tourism, can thank the Luttrells for their generosity in the Victorian era with making land available for development.

I hope you enjoy reading about these two places as much as I have enjoyed researching them.

A

Avenue, Minehead

In 1874 The Avenue was deemed as unfit for purpose by a visitor to the town who urged that something should be done to improve it as soon as possible. Perhaps knowing that the road was formerly called Watery Lane and prone to flooding may explain this! Just to confuse matters the current Watery Lane is situated elsewhere in the town.

The success of the railway, which had opened in 1871, led to steady development of this area of town. The road had been prepared in anticipation, but was not tarmacked, resulting in a muddy mess for all. Forming the main street in the town along with The Parade, it is wide and lined with trees, which are festooned with lights all year round. Shops abound offering regular High Street brands, seaside toys, charity shops, clothes and tattoo parlours. There are plenty of eating places, with pavement cafés to enjoy a coffee or a Somerset cider, all set among the late Victorian and Edwardian houses.

The oldest property on The Avenue is the former courthouse or Manor Office, which dates back to the fifteenth century. At one time serving as a tearoom for visitors and now a flower shop, many of the original features are buried beneath more recent alterations, enabling the building to function in the twenty-first century. Externally there are oak windows dating to the fifteenth century and around the corner onto Summerland Road is a solid oak door frame dating from the same period.

Further along this side of The Avenue is the Regal Theatre. It opened in 1934, having been built for Minehead Entertainments Ltd and operated by the Jay family until they sold it on retirement in 1968. The architect was Andrew Mather, who designed many cinemas for the Odeon chain and was based in London. It seated 1,250 and included a ballroom. The site wasn't always as glamorous, having previously been a tannery. It is now run by a group of amateur theatrical societies embracing all forms of dramatic art – film, theatre, music and much more. In 1981 part of the building (stalls and ballroom) was converted into a supermarket, initially Woolworths, and is currently a bargain store.

The tannery was a Minehead business first under the ownership of the Siderfin family, then the Evans family, who continued to trade under the Siderfin name. It was established in the eighteenth century, providing the very best leathers. Hides from

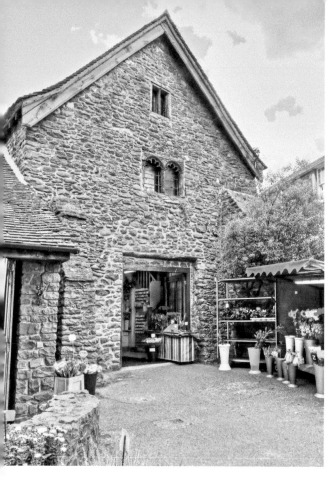

Left: The former Manor Offices on The Avenue, now a flower shop.

Below: The Regal Theatre is almost hidden in the street scenery, especially in the summer months.

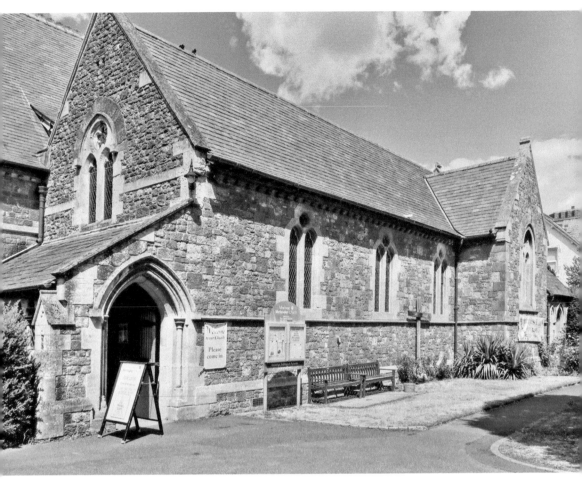

Minehead Methodist Church.

South America bought via brokers in Antwerp were processed, with by-products being for use in gelatin-based items. At its peak 150 to 200 hides per week were processed, the whole procedure for one piece of leather taking approximately fifteen months. The whole process was done by hand to achieve the highest quality.

On the opposite side of the road is the Wesleyan Methodist Church. John Wesley visited Minehead twice on his way to South Wales in 1744 and 1745, preaching on the beach each time. The early history of Methodism in the town varies depending on the source but we can be sure that the home of Mr and Mrs Stoate, Bampton Street, was used for meetings for a considerable period of time. A chapel at Alcombe was built in 1850, but eventually land was sought from the Luttrell family who leased the current site at a cost of £8 8s per annum. The church was built in 1877, with additions made in 1886 and alterations over the years as the needs of the worshipping congregations have changed. The original architect, Mr Joseph Wood of Foster and Wood, Bristol, had devised a scheme whereby additions could be made as money permitted, his first

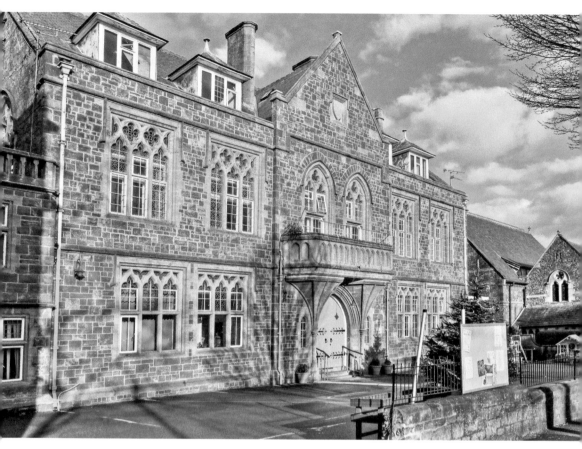

The front view of the former hospital on The Avenue.

plans being too expensive. In 1904 a new schoolroom was begun, and a stone-laying ceremony took place in October. This was very much a family occasion and a tin was placed in a cavity under the first stone naming all the children and families that had taken part in laying twenty-two stones around the new building. Mrs Gane of Bristol laid the first stone, which is situated to the right of the front entrance to the building. The schoolrooms opened in 1905 and were also used during the war as the main school for the children of the parish.

The next building of interest is the former Minehead hospital. It was originally built as a public or town hall in the Gothic Revival style by James Piers St Aubyn and finished in 1889 for a private company. Various entertainments, meetings and exhibitions were held in the large hall, which sat over 500 people. When this private company went bankrupt in 1910 the building was sold to the Wiltshire and Dorset Bank, who made alterations suitable for their needs. Shortly afterwards the bank was taken over by Lloyds, who already had a bank on The Parade from their takeover of the Devon and Cornwall Bank in 1904. Inevitably the hall became surplus to requirements and was used as a Red Cross Auxiliary Hospital in 1915, expanding from its capacity of

fifty patients to 120. At the end of the war it became the Luttrell Memorial Hospital, merging with the hospital in Dunster and finally closing in 2011 when the newly built hospital on Seaward Way opened. Many alterations and additions have taken place over the building's life, some of which have been essential to the smooth operation as a hospital but to the detriment of the original building. As of 2019 it is in the hands of a company whose aim is to create a community hub in a tastefully restored building. Already in situ is West Somerset Radio broadcasting to the region.

Avill River, Dunster

The River Avill rises near Dunkery Beacon on Exmoor with tributaries joining along its route. The A396 follows the river's natural course until it reaches the outskirts of Dunster. Here the river passes under Old Frackford Bridge, Gallox Bridge with its old ford, and by the working watermill at Dunster Castle. Continuing on its journey it passes through Dunster Park (and a couple of ornamental bridges built for the Luttrell family), then under Loxhole Bridge with the flood relief channel dug in 1964 and eventually away into the sea. The relief channel is controlled by a sluice gate, which diverts water away from Dunster Marsh.

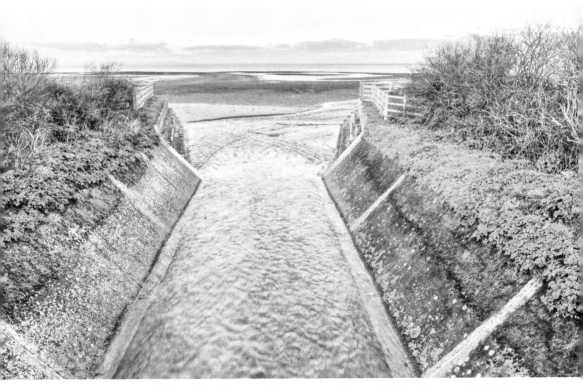

Here the Avill Relief Channel can be seen flowing out to the sea. Much of the year this is dry.

Bampton Street, Minehead

If this street had one claim to fame it would be as the location in which the fire of 1791 began. An enterprising (or foolish in the midst of so much thatch) miller had been burning a tar barrel as an experiment. Wind blew the flames to a nearby furze pile in his yard, which then spread to nearby thatched roofs. Over seventy-two properties were lost but fortunately with only one fatality – a 'poor maniac', Mr D. Price, who was confined and forgotten about until too late. Few of the houses were insured but a public appeal to assist those who had lost everything was made. Total uninsured losses were estimated to be upwards of £18,135 (approximately £1.4 million). One paper described how the centre of this once respectable and flourishing maritime town was now a heap of ruins. A few of the good houses were not destroyed and this presumably included Bampton House, which has a grand carriage entrance sporting a lions head and a pair of decorative pineapples. Lions represented strength and pineapples wealth. Later these became an indication of hospitality.

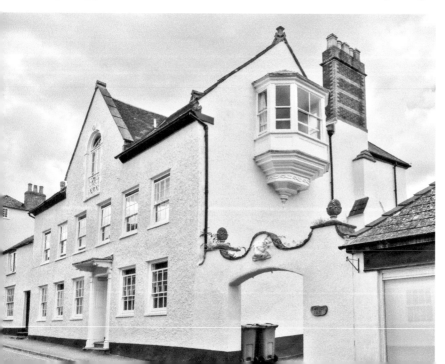

Bampton House, Bampton Street, with its impressive carriage entrance.

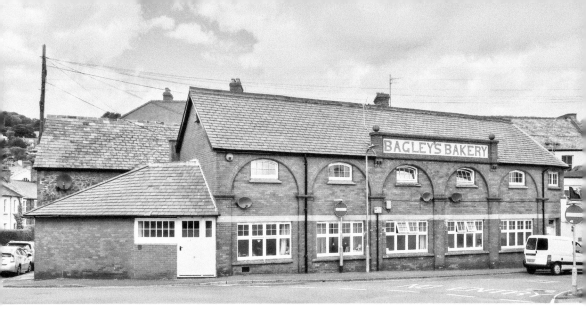

Bampton Street, Minehead – the former Bagley's Bakery.

The Bratton stream, which flows from the hamlet of Bratton and is now partially diverted underground, made Bampton Street a good site for the town's two grist mills. The last remaining mill building is now converted into sheltered accommodation while still retaining the external appearance of a former mill.

Opposite is Bagley Mews, the former bakery that was in operation at the beginning of the twentieth century. The building still bears the signage and appearance of the bakery, having been tastefully converted in around 2006.

Bancks Street, Minehead

Bancks Street takes its name from the family of the same name. Jacob Bancks was born in Stockholm and came to England as a secretary to his uncle, who was the Swedish ambassador. Jacob took a commission in the British Navy and on marriage to the widow of Francis Luttrell, Mary (née Tregonwell), in 1696 he retired on half pay. He was MP for Minehead from 1698–1714, and was knighted in 1699. He presented the town with the statue of Queen Anne, which is now on Wellington Square.

Until the development of the town in the late Victorian era this street comprised a small park or square with a smithy tucked away at the back. Exmoor Masonic Hall was founded in 1889 and Exmoor Lodge granted its warrant in 1891, having initially met in the Town Hall. The current hall was dedicated in 1896 and a new Masonic lodge was added at the back in 1923. The carvings are by William J. Giles of Wellington.

On the closure of the Town Hall Mr Henry Wood converted his furniture warehouse on Bancks Street for entertainment purposes. Now containing flats and called The Courtyard, it became the Cosy Cinema, seating 350 people. The Central Hall or Pavilion, with fitted stage and use of a piano, could be hired in 1911 from its owner. The manager by 1914 was Mr F. D. Fraser and then retired actor Mr Ernest Heathcote

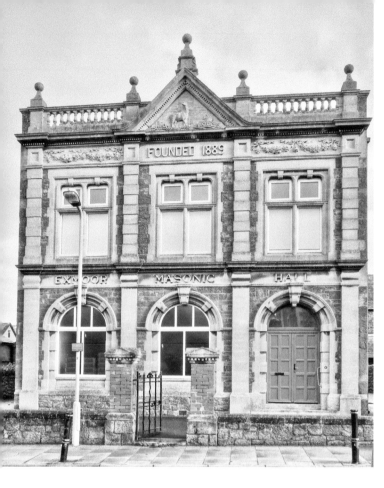

The Exmoor Lodge Masonic Hall on Bancks Street. Note the fine carving of the stag.

(proprietor of the Beach House Private Hotel and described at times as 'an eccentric comedian') by 1923. There were applications for theatrical licences by him in 1928 for the Cosy Cinema, Concert Pavilion and Queen's Hall.

Another group that initially met in the Town Hall was the Congregational Church, who first convened in summer 1902. By 1903 they were advertising for local builders to tender for the 'erection of a proposed Sunday School', eventually choosing the architect F. W. Roberts of Taunton. Freehold land was bought from Mr Luttrell and in November of the same year the corner foundation stone was laid by Alderman Manchip of Bridgwater, at a special service attended by many from across the county. The site abutted Irnham Road and was to house both a chapel and substantial two-storey Sunday school with a meeting hall and two upper storey classrooms. The building material was red sandstone and the style was to match that of the Masonic hall, all costing £950. By June 1904 services were advertised as taking place in the newly finished building. This is now the United Reformed Church.

The Quaker Meeting House at No. 9 was built in 1903 for the Plymouth Brethren, who sold it to the parish church in 1908. Used as the church hall until 1958, it then became a photography studio and shop for L. T. Blackmore. In 1976 it reverted to its original religious purpose, becoming a meeting house for the Quakers. Originally Quakers had a meeting house on the corner of the street known as the Butts until a newer one

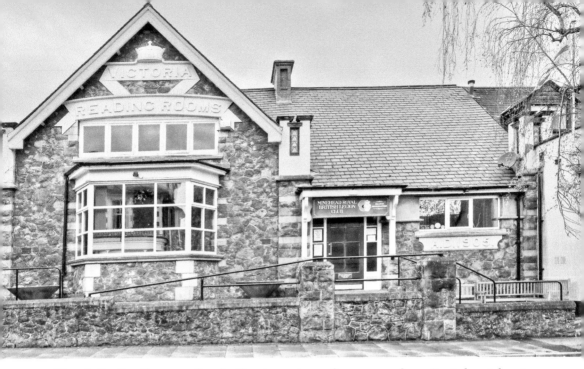

Victoria Reading Rooms on Bancks Street were in use from 1905 and are situated next door to the town library, and are now part of the British Legion Club.

was built in the Market Place. The first meeting was set up by William Alloway, who arrived in the town before 1663. He married Susanna Lynd in this year and was a prosperous merchant. George Fox, the founder figure of the Quaker movement, visited the meeting house in 1668. Some of the first Quaker family names from the town were Devonshire, Clothier, Bond and Davis. Robert Davis set up a pension scheme and a hospital for sailors and their dependents in around 1738, and William Davis started a subscription to help the homeless following the 1791 fire. By 1814 the meeting closed and the building on Market Place was used as a school before being demolished in 1822. It took over a hundred years before a meeting began again during 1938 in hired rooms. In 1975 they had the chance to buy their current home on Bancks Street, and following adaptation for their purpose began using the property in 1976.

The Church Institute (1895), the Victoria Reading Room (1905) and the Royal British Legion (1905) all have their homes down this street, as well as the current town library.

Bats Castle, Dunster

Bats Castle is one of two Iron Age archaeological sites around Dunster Castle estate and deer park. If you decide to walk to see these make sure you allow plenty of time, and take a good map and GPS device as everyone I have spoken to seems to get lost in the many paths around the hill. What once started off as a gentle evening stroll with my husband turned into a 7-mile hike – fortunately in high summer, days were long! However, the views are stunning across the hills towards Exmoor so it is well worth the effort.

Woodcarving of a bear in the woods around Bat's Castle.

Bats Castle is an Iron Age hill fort that would have been a good place defensively, and was once known as Caesar's Camp. It is circular with two banks, some of which were still 15 feet high when Pevsner wrote a guide in 1958. A smaller camp below called Black Ball Camp or British Camp may have been an outpost. Both are situated on Gallox Hill to the south of Dunster Castle. Make sure you watch out for the bear!

Beach, Dunster

Dunster Beach is a hugely varied area. Not only is there the beach and its associated wildlife, but a holiday camp with an interesting history. There is evidence of Second World War activity taking place along this coastline and you may see the remnants of pillbox sites. It is believed that these may have been joined by trench systems, although nothing remains today. There were also aircraft obstructions – posts placed at intervals along the coast to prevent enemy aircraft landing. Again nothing remains of these.

It is possible to walk along the coastline from here to Minehead but for those who require gentler exercise there is a nature trail around the beach and chalet area aimed at older children (I suspect that those younger than the suggested age of ten would enjoy looking out for the flora and fauna too). Highlights include the wildlife including badgers (this is where I saw my first wild badger), bats and birds (moorhens, herons, reed warblers and geese). Some of the flowers that can be found, depending on the season, are yellow horned-poppy, prickly sandwort, viper's bugloss (which is rare elsewhere), roast beef plant, restharrow, mossy stonecrop (which you may find under your feet if

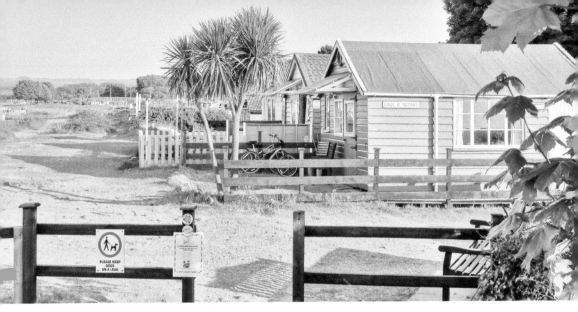

Holiday chalets at Dunster Beach.

you look carefully as, although tiny, it is bright red in spring), false bullrush and more. Some nationally scarce plants have been identified along this stretch of shoreline: smooth catsear (the only known site in South West England), bulbous meadow grass, mossy stonecrop, suffocated clover and sand catchfly (now thought to be present on the nearby golf course as well). The noted female botanist Isabella Gifford studied the plant life along this shoreline during her forty years living in Minehead.

Bathing huts were being developed at both Minehead and Blue Anchor leaving Dunster Beach as a natural area. Dunster Trading and Transport Company, established in the 1920s as a separate concern from the Dunster estate, had the aim of creating holiday dwellings as a business. In 1933 a newly erected beach hut was advertised to rent, equipped for four. At the outbreak of the war in September 1939 fifty huts were requisitioned for evacuees at both Dunster Beach and Blue Anchor. Nissen huts were erected for the military who were building the coastal defences in the area, as mentioned earlier.

At low tide you may see lines of fish weirs. These comprised of posts placed at angles with nets strewn from post to post. Rents for the use of a weir would be paid to the lord of the manor.

Long before any of these it was a busy area for shipping, more of which can be read in the section on the Hawn.

Blenheim Road, Minehead

The development of the 'New Road to the Quay', or Blenheim Road, was not without disaster. During building work in 1870 scaffolding broke and it was suggested that with four men and a large amount of stone, it was overloaded. Fortunately despite the fall to the ground and being buried under the stone no injuries greater than one broken finger and cuts and bruises were sustained. Along here was the manse for the

The terrace of late Victorian and Edwardian houses along Blenheim Road.

Methodist minister, home of the former optician, jeweller and now property developer Mr J. B. Marley (of Marley's Victoria Brick and Tile Works at Alcombe) but the most famous resident is probably Sir Arthur Charles Clarke (1917–2008), who was born at No. 4, which is marked with a blue plaque. Clarke was a prolific author of over 100 books, including *The Sentinel*, on which the film *2001 A Space Odyssey* was based.

Back to property developer Mr John Marley, who built Blenheim Terrace in 1895. He nearly became a victim of the 'Spanish Prisoner Trick'. In the 1904 version of the modern-age spam 'send us money to release our inheritance and you will acquire great fortune', Mr Marley received a letter from an imprisoned Spaniard claiming to be his brother-in-law, now a widower, with a daughter, Amelie, left protectorless. In order to claim the money he was to send Amelie funds to redeem luggage from the Spanish government who were holding it. Within the luggage was the deposit slip for monies gained during the Cuban War, and banked in England. Mr Marley saw through this saying he neither wanted to gain a niece or a small fortune and that the Spanish prisoner would have to look out for a more 'credulous relative'.

The former police station, active as such between 1897 and 1936, backed onto the hospital and in 1935 plans for extending the hospital required extra land. Joint discussions led to the proposal that the police station and land be sold to the hospital authority if they, the police, could find a suitable alternative site, which they did on Townsend Road.

Blenheim Gardens, Minehead

Blenheim Gardens was developed in the second decade of the twentieth century, officially opening in March 1925. The newly laid out gardens, which took a year to create by landscape gardener Mr E. White, included semi-tropical plants, flower beds, walks and a bandstand. This was partly funded by Mr R. Magor of Northfield, who performed the opening ceremony. Initially it was Blenheim Fields, then Blenheim Meadow and finally becoming called Blenheim Gardens in the 1920s. In the 1840s

there was a limekiln on the site and in the early twentieth century a lawn tennis court. A rain gauge and a gun were marked on an early map but the gun was dismantled in 1937 for scrap, with the full support of the British Legion. A reporter in the *Taunton Courier* wrote, 'As they disappear one by one into the smelting furnaces for the making of more armaments it is fervently to be hoped that in their reincarnated state they will be permanently unemployed'. It was a German gun and a souvenir of the First World War. A plaque, now on show in the town museum, was mounted pronouncing 'Captured German Field Gun – presented to the town of Minehead by Somerset Territorial Force Association in recognition of the townspeople's efforts in the Great War 1914–1918'. As the years went on these reminders became more upsetting to those who were so badly affected by the war. Within two years of its removal the threat of further conflict was more than just a rumour. A more recent war memorial, erected by the Burma Star Association, was dedicated in 1999.

As I was writing this, the announcement was made of the closure of the much-loved café run for fifty years by two generations of the Griffiths and Dean family, who have been tenants since 1968.

The bandstand and gardens have been the scene of many entertainments over the decades: in June 1929 the band of the 2nd Battalion of Gordon Highlanders performed for a week; in August 1933 Evelyn Hardy and her Ladies Orchestra; and in June 1956 Prince George's Guard and band from Denmark made a visit. The gardens continue to delight generations both young and old with concerts in the Edwardian bandstand, some traditional and others a bit more modern.

The beautifully laid-out and maintained Blenheim Gardens.

Burgundy Road, Minehead

Burgundy Road was built as a new road in 1888 following the construction of the impressive Elgin Tower on the corner of St Michael's Road. Built of local red sandstone in 1887 in Scottish Baronial style, it was intended for retired Scottish confectioner James Christopher Kennedy who tragically never lived there. After his death in 1894 widow Joanna married Archibald Cook and as Mrs Kennedy-Cook she did for some time reside in the house. It was also let out to various notable people: in 1905 William Reginald Valentine Webb, associated with brewers Webbs (Aberbeeg) Ltd. (there will be more on him later); and in 1908 Mr and Mrs McClymont Reid, who had a polo team named Elgin Tower. Mr McClymont Reid was the honorary secretary of the West Somerset Polo Club and he and his wife lived there for a couple of years. When Mrs Kennedy-Cook died in 1919 there was an auction of the contents of the house which had been furnished with antiques.

By 1920 it had become a hotel and the advert in the Ward Lock guide to North West Devon of the same year declared it to be 'FIRST-CLASS. Beautifully Situated in Own Grounds of three acres. Its Position is Unique and Commands the Finest Sea and Moorland Views in the West of England. Excellent Cuisine. Palm Lounge, Roof Garden (where Afternoon Tea is served). Orchestra during Season. Tennis Court. Garage. Electric Light. Open All the Year. Five minutes from Station and Sea. R.A.C. Appointment.'

Hotel manager and one time boarding house keeper of Elgin Tower, Charles Vickers Wood, was, in 1921, wanted for not appearing at his bankruptcy hearing. It turned out that he had absconded from a guest house in Bath, leaving debts. In late November a warrant was issued for his arrest.

Adverts for staff continued throughout the 1920s but by the outbreak of war the house was empty. It has also served as Provident Insurance Company HQ, a girls' school, as well as a private residence including, for a period, squatters. In recent years it has been completely restored.

Elgin Tower on Burgundy Road was one of the first houses built on North Hill.

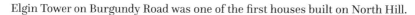

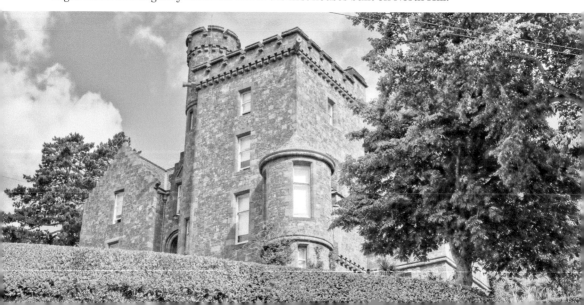

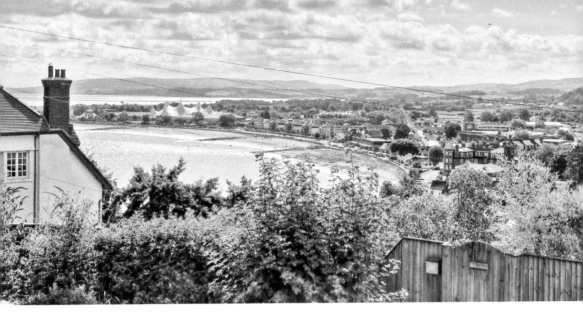

View of Minehead and beyond to Blue Anchor Bay from Burgundy Road. Butlin's Skyline Pavilion is clearly visible.

Butlin's, Minehead

Billy Butlin applied to build his holiday camp at the end of 1960. Despite local objections the site was founded in 1961 as a part of the Butlin's empire, opened the following year and still in business today and going from strength to strength. The Skyline Pavilion, visible for many miles around, was added as well as Bayside Apartments, increasing the range of accommodation from the original chalets synonymous with the English holiday camp many still remember. It was at Minehead Butlin's that Francis Rossi, who was performing with his then band, the Spectres, met Rick Parfitt, who later joined forces with Rossi in Status Quo.

Butlin's has moved on from the days of chalet accommodation. You can now spend your break in this luxurious block of apartments.

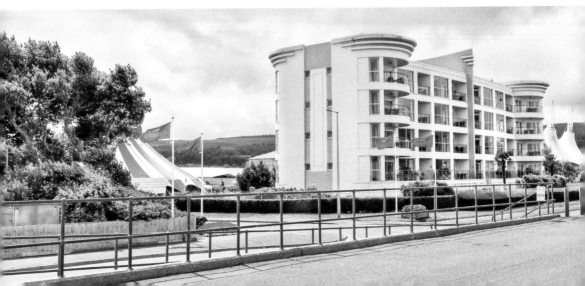

Castle, Dunster

As has been seen with Bats Castle there has been some form of stronghold in the area for centuries. By the time of the Domesday Book in 1086 it was recorded that 'Aluric had held it' (the manor of Dunster). It was passed to the De Mohun family, who held it until it was sold to the Luttrell family. Except for brief spells during the War of the Roses and English Civil War it remained in the Luttrell family until 1976 when it was given to the National Trust.

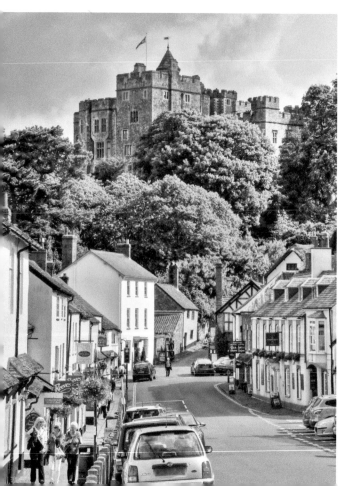

Dunster Castle as viewed from High Street.

De Mohun had a motte-and-bailey castle on the site and it is hard to imagine that at one time it was a fortress on top of a steep and treeless tor, although King Stephen, in 1138, described the castle as inaccessible on the seaward side as it was washed by the sea and fortified with towers, walls and ditches on the other.

During the Civil War it switched hands between Parliamentarians and Royalists. Luttrell was a parliamentarian and in 1643 swapped sides on surrender to the Royalists. General Robert Blake led the siege of Dunster Castle for the Parliamentarians. It was after this war that it became a home rather than a castle.

The current building was designed by Anthony Salvin for George Fownes Luttrell, who came into possession of it in 1867. He was assisted by St Aubyn, who became the retained architect for the Luttrell family, his work being scattered throughout Dunster and Minehead. Charles H. Sansom also assisted and was involved in the development of Minehead with St Aubyn.

During the Second World War it was a convalescent home for injured naval officers.

Castle Mill, Dunster

The restored eighteenth-century watermill, now run by the National Trust, continues a tradition of mills dating back before the Domesday Book when two corn mills were in existence. The lower of these was known as Nethermylle. Newmylle, built in the fifteenth century next to Nethermylle, combined with the latter in the seventeenth century to form Lower Mill, which is the mill still standing today. At the peak there were four working mills that were connected to the cloth industry in the village. Castle Mill had new machinery installed in the eighteenth century and again in the late nineteenth century, replacing wooden mechanisms with iron. It fell out of use to then be restored for use during the Second World War with a bakery. It was then used to grind cattle feed until the 1960s. After a further period of disuse it was restored again to full working order and can be seen producing flour on a regular basis. Water is diverted from the River Avill by a leat, which runs down Mill Lane, to power the unusual double overshot mechanism.

Church Steps, Minehead

Church Steps is only accessible on foot and the relatively steep climb leads up to the parish church of St Michael. At the foot of the pathway there is a red sandstone building that was used as the parish poorhouse in the eighteenth century until a new workhouse was built on Middle Street in the 1820s. Prior to this it was the house of correction where petty criminals would be locked up to pay penance for their crime.

Further up on the right-hand side is Smugglers' Cottage, which is thought to be one of the least altered seventeenth-century cottages in Minehead. A cluster of white-painted thatched cottages completes the scene as the church looms large ahead.

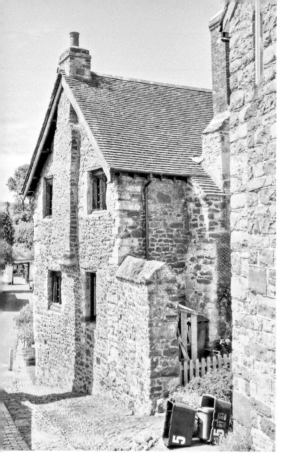
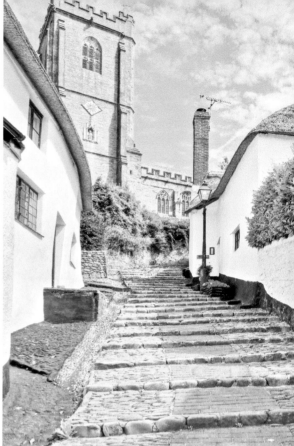

Above left: The former poorhouse on Church Steps.

Above right: Church Steps lead the walker through the midst of some of Minehead's oldest cottages up to the church.

Church Street, Dunster

Church Street, a narrow stretch of road after the wide aspect of High Street, has several buildings of interest. The Nunnery can be found as a separate entry. Other equally old buildings are cottages Nos 26 and 28, which have beams with a tree felling date of the fourteenth century. Although other properties may look more recent – i.e. eighteenth century onwards – there may be alterations made to an older property such as the shopfront at No. 14–16.

In 1879 you could buy a monkey jacket for '9 shillings and 11 pence at Culverwell's, Church Street, draper, grocer, boot and shoe and general stores'. John Henry Parham took over the shop at Nos 22–24 and was trading there in the early twentieth century. Another resident and tradesman of the town lived at No. 10: Mr Samuel Ell, a chemist originally from Berkshire who moved to the village during the 1860s and married a Dunster girl. They raised a large family from their home on Church Street and when he died it was remarked that he had won the respect and esteem of all

who knew him. He served the town, not only as their chemist but as the dispenser for the Dunster and Minehead Cottage Hospital, as a member of the parish council, treasurer for the Ancient Order of Foresters and a member of the Baptist church. Hopefully his claim to fame isn't all he is remembered for – Dunster Marmalade, which was described as 'pure, wholesome and delicious!' A letter of thanks was received from the Peers' Refreshment Rooms manager in Parliament, who served it to the gentlemen for breakfast. The preserve was made on Ell's premises, in an upstairs warehouse.

Church Street, Minehead

With cottages dating from the early seventeenth century, this is a lane that survived the fires of the eighteenth century. It is believed that some cottages may date back to the 1500s. The street has naturally developed during the last century with the addition of housing built on the site of a former orchard – the cul-de-sac Orchard Road. Gardens on the other side of the lane front some larger houses. This was the original route down to Quay Lane and then to the quay itself, also down to the main town via Holloway.

At the bottom of the street are two red-brick buildings – the old Parochial Schoolrooms. The first was designed by St Aubyn, with the foundation stone laid in June 1865, to comprise accommodation fit for 216 pupils. The £1,000 cost was met by the Luttrells and the building was opened in 1867. Education was not free so a fundraising concert shortly after the opening in 1867 raised the princely sum of £5 for schoolbooks. In 1898 the second building was designed by local architect William Tamlyn, and is remarkable as it still has the original diamond pattern concrete roof tiles. This design came from Germany and the tiles were probably made on German machines in English factories. Infants remained in the older building and juniors moved to the new.

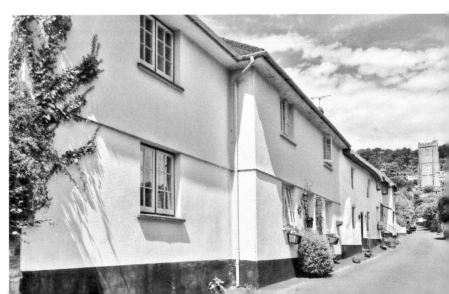

Church Street, Minehead, appears on earlier maps as Middle Street, while what was Church Street became Vicarage Road.

The former town junior school at the bottom of Church Street. Note the roof tile pattern.

Conduit Lane, Dunster

Conduit Lane leads to St Leonard's Well, which dates from the eleventh century and the well house from the sixteenth century. Water was directed to the well house from the side of Grabbist Hill and then to the priory where it fed two water troughs. The monks used it for both the priory and their farm. Apparently the ghost of Mother Leaky lives here. When I walked this in January the whole pathway was under running water despite no rain.

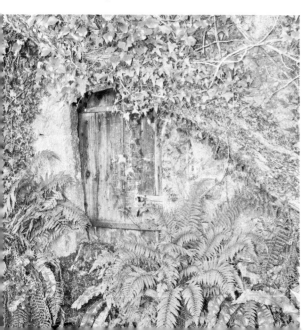

St Leonard's Well, hidden behind a locked door.

Conygar Tower, Dunster

Conygar Tower is a folly built late in 1775 for Henry Fownes Luttrell and designed by Richard Phelps. It is approached by a 'ruined' gatehouse, and comprises four storeys. When Luttrell was creating his pleasure gardens and deer park this folly was his eye-catcher. At the top of the tower a cannonball hole is reputed to have been made by a canon fired from Watchet. Conygar Hill, as the name suggests, was the home of rabbits, which was a huge problem in the thirteenth century. Following a programme of extermination (this was the wording in the newspaper report from which this was taken), by 1266 the hill was rabbit free and turned over to pasture. There were rumours of a passage from the tower to Dunster Castle half a mile away.

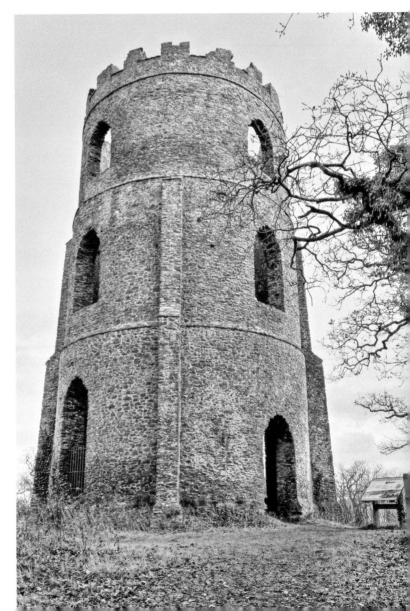

Conygar Tower, which can be seen in the local landscape for many miles around.

Culvercliff, Minehead

This area to the west of the harbour is now given over to recreation but was formerly the site of small industry. Maps show evidence of nineteenth-century gravel pits, limekilns and the town gasworks which were built here in 1868 to take advantage of coal brought in by boat. The site is now occupied by a car park and the lifeboat station.

In the 1870s it was a good place to watch the regattas held in Minehead but approximately 2 acres of newly planted Scots pines must have signalled the end of viewing. Regrettably these trees were destroyed by fire in August 1885 – accidental following a prolonged period of hot dry weather. Replanting took place and in 1899 it was described as a 'young plantation'.

The shore along here comprises stone that was used in the construction of the seafront wall. Boats would pull onto the shore, load up and sail back around the harbour to offload their cargo. However, all did not go well for Captain Pulsford and his vessel *Henry*. Loaded, the crew tried to relaunch it but in a tremendous swell found themselves and the boat battered under the cliffs. The crew were rescued but when the boat was inspected it was found to have rocks coming through the bottom. The loss was all Captain Pulsford's, as he was uninsured.

Later in the same decade the town council discussed the area as a potential place for rubbish disposal. It appears that rubbish had been disposed of at the sea end of The Avenue and as an alternative councillors proposed that Culvercliff may be a better option as they thought that the tides would sweep the rubbish away. Mr Rawle, with his extensive knowledge of tides and currents, told them they were wrong and that it would all be washed back in along the whole of the beach.

More recent changes include a pillbox as part of the coastal defences along this stretch of coastline during the Second World War. As part of the landscaping it is possible to walk from here to Greenaleigh Farm and other North Hill locations.

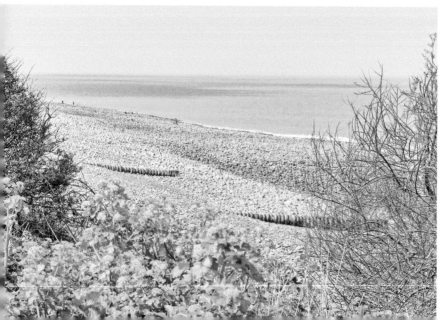

Culvercliff, beyond the quay and the stony beach.

D

Dovecote, Dunster Priory

The fourteenth-century dovecote forms what would have been part of the Benedictine Priory Farm. Along with the rest of the farm it became part of the Dunster estate. The Dovecote has some sixteenth century additions, and the revolving ladder (or Potence)

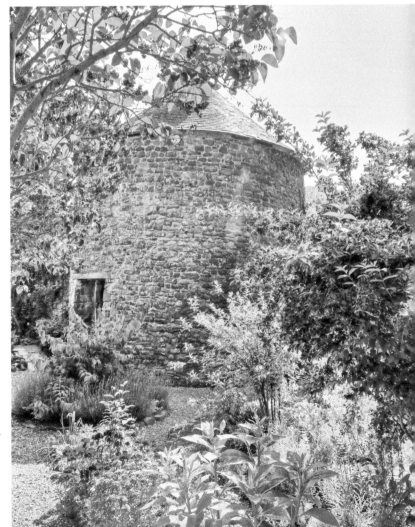

Dovecote, formerly part of Dunster Priory Farm, viewed from the adjoining garden.

is possibly nineteenth century. This ladder would have been used to access the nests for removal of the young birds. In the fifteenth century 2,000 squabs (the culinary term for a domestic pigeon, usually under four weeks old) were provided to the kitchens annually.

Dunster Shows

Dunster has two main shows in the summer: the country fair and the agricultural show. Both are held on Dunster Lawns during the summer.

The Dunster Show celebrated its 172nd year in 2018 and describes itself as the premier agricultural show in West Somerset. You can see prize cattle, sheep, horses, falconry displays, the latest farming equipment, the ubiquitous trade stands and craft stalls and so much more. Expect to have a long and varied day out. Dunster Country Fair has demonstrations of canine and equine nature plus the craft and trade stands. Another long and varied day out.

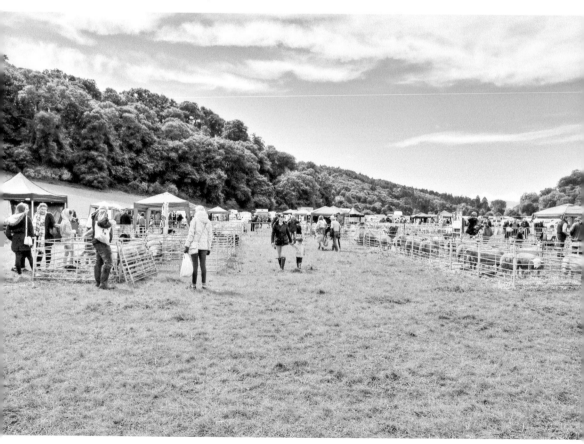

The Dunster Show against the backdrop of the surrounding hills of Exmoor.

E

Esplanade, Minehead

The Esplanade will be one of the most familiar sights to the visitor whether approaching the town by rail or car, running for a short stretch opposite the railway station to the Blenheim Road junction with Quay Street. Before 1900 this pleasant walkway and wide road didn't exist and the front gardens of the existing small terrace of houses and the Esplanade Family Hotel ran down to the shoreline. By 1900 proposed improvements to the area were underway with land given by the Luttrell family for this purpose. In the spring of 1901 foundations were laid under the supervision of a clerk of works appointed specifically for the role. Mr Luttrell made suggestions for species of trees to plant that would be hardy faced with sea winds. A selection of wych elm, elm and sycamore trees were chosen and ordered from a company in Scotland (raised in Scotland, it was thought they would be hardy) at a cost of 35s for the 100 to be ordered. Existing gas lighting would be extended and the Esplanade was created. The work was finally completed at the end of August and the workers were treated to entertainment before they returned home to Cardiff.

Naturally it made a wonderful spot for open-air entertainment. One year The Mascots, a high-class concert party, offered entertainment twice daily during the season, both in the morning and evening on the Esplanade. On the August bank holiday (which happened earlier in August than these days) the new Esplanade thronged with visitors who were entertained by the Town Band, The Mascots and The Welsh Glee Singers.

The Esplanade Family Hotel was completed in 1893 for Mr Thomas Ponsford, built by J. Langdon in the familiar local red sandstone. St Aubyn was again the architect along with Wadling. When it opened, with all sixty bedrooms furnished by Bristol firm Trapnell and Gane, manager Miss Tyack would have welcomed the guests into a huge entrance hall with skylights over 50 feet above. There were galleried landings, gas lighting, a dining room overlooking the sea, billiard and smoking rooms. There were acres of grounds that would be laid out as gardens with tennis courts. Those that could afford their own transport would find stabling and coach houses available. In 1898 it was renamed the Metropole and in 1913 a ballroom extension was added, which was designed by architect John Kingwell Cole, who also designed a palace in Simla for the Maharaja of Patiala. During its heyday as a luxury hotel it played host to the Jodhpur polo team (1925) and after the polo tournament a ball was held in the hotel. During the Second World War it was an army training centre dealing with

motor maintenance. In 1960 part became the Hobby Horse Inn, taking its name from an ancient Minehead custom, while the remainder was converted to flats.

Also along here you will see Foxes Hotel, and may well have seen other 'Foxes' property around the town. Foxes Hotel describes itself as 'a very special place' and 'the UK's only training hotel for young people with learning disabilities.' Established in 1996, it offers vocational training with work placements and teaching independent living skills so each pupil achieves their full potential.

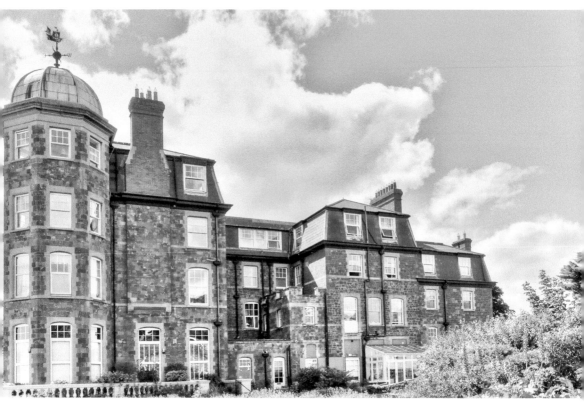

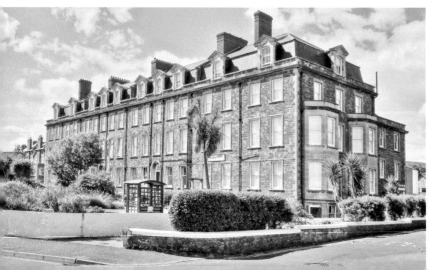

Above: The Hotel Metropole, one of the grandest establishments in town.

Left: Foxes Hotel on the Esplanade.

F

Floyd's Corner, Minehead

Floyd's Corner is on the corner of Friday Street and The Parade. This was so named after the department store that was there for over 100 years. The original corner shop unit was occupied by John Bond, a draper, chemist and grocer in 1875. Meanwhile Isaac Floyd founded his store on Friday Street in 1877 (adverts also have the address as Wellington Square) as a 'ready money drapers' offering millinery and drapery. Goods could be offered cheaply as no credit was involved. A February sale was offering hats for 3¾d each in 1881, a third of the normal price. By 1897 Floyd's store had expanded and continued to expand along The Parade

Floyd's Corner is named after the former department store.

using both ground and upper floors for showrooms. In 1910 it was advertising the cheapest ladies jackets, ladies costumes and furs; as the cheapest house for dress goods, for blouse materials, lace goods and drapery goods; and as the cheapest store for menswear, womenswear and children's wear. By the mid-twentieth century it was a department store and producing town guidebooks. It finally closed in the 1980s having celebrated the centenary a few years before.

Friday Street, Minehead

Friday Street formed part of the medieval town but much of it was burnt in the fire that started in neighbouring Bampton Street. Before the fire there is evidence that there was the 'new' hall here in the seventeenth century, and also evidence that the market moved here when this new town hall was built, although no site has been identified.

Major development took place in the early twentieth century, which is reflected in the architectural style. The *Taunton Courier and Western Advertiser* in 1937 suggested that the street name was either to do with poverty or fish, stemming from the custom of fish on Friday. It was also suggested that maybe the original fish market was here.

It is still the home of plenty of individual shops. A long standing business is the Gentleman's Hairdresser, established in 1887 and still run by the Bale family. It has also been the home of local builder and undertaker J. H. Hurford, who moved here

Friday Street viewed from St Andrew's Church.

from Bampton Street, making Warwick House his home in 1909. A tearoom with the name of Ye Olden Tymes was here in 1904, and in 1906 Minehead and District Co-operative Society Ltd had its store here. Monumental sculptors 'Slade Brothers', established in 1843, had their premises here, no doubt producing a quantity of select gravestones and statues for the local churchyards.

Frier, Harry

Henry Frier was born in Edinburgh on 2 May 1849 to parents Robert and Margaret Frier. He was known as Harry throughout his life and was educated at home by his mother. His father was a stocking manufacturer by trade, with some artistic talent (in fact he sold his interest in his factory to become a full-time artist). Harry was taught the basics of drawing and painting by his father before attending Edinburgh School of Art from 1867 to 1870. He then went on to various teaching roles in Edinburgh before being totally self-sufficient as a painter. Despite an accident to his eye he was able to master his disability and continued to paint. He first came to Somerset when his fiancée Kezia Catherine Dyer (Kate) brought him to meet her mother. The couple had met in London where Kate was on the stage. Marrying in Taunton in 1881, he later became employed by Charles Tite, one time secretary of the Somerset Archaeological and Natural History Society, to record Somerset scenes which he did over the next ten to fifteen years. Kate's younger sister, Polly Dyer, had a boarding house in Minehead and Harry visited in the latter years of the nineteenth century, producing sketches and watercolours of the town. Had it not been for this work he may not have survived as an artist as the postcard industry began to flourish taking advantage of the commercial nature of that business. After what appeared to be an unhappy marriage Kate died in 1913, leaving Harry grief stricken, perhaps realising what they had been to one another. He died in 1921 a shadow of his former self but leaving a legacy of sketches and paintings of Somerset for future generations. Some of his Minehead illustrations include *Door of old building* (1899) (Old Priory, The Avenue); *Cottage on the north side of Quay Street* (1901); *A cottage* (1899); *On North Hill* (1901); *North Hill and the Harbour from the east* (nd); *View from the Quay looking east* (1899); *Minehead Harbour* (1905); *Minehead North Hill and Harbour* (1916); *Holloway Street Minehead* (nd); *Quirke's Almshouses* (1901); *Minehead pier looking towards Dunster beach and with Conygar tower beyond* (nd); and *Demanding Toll, Minehead* (1902).

Gallox Bridge, Dunster

Gallox Packhorse Bridge, situated at the end of Park Street, spans the River Avill on the south of the village. It is recorded in the fifteenth century and is adjacent to a ford as was the common practice on Exmoor. The sides are low so that the packs on the horses would not be impeded by higher parapets or walls ensuring ease of passage across the narrow bridge. This bridge is mentioned in Dunster Castle documents from 1490.

Gallox Bridge passes over the River Avill.

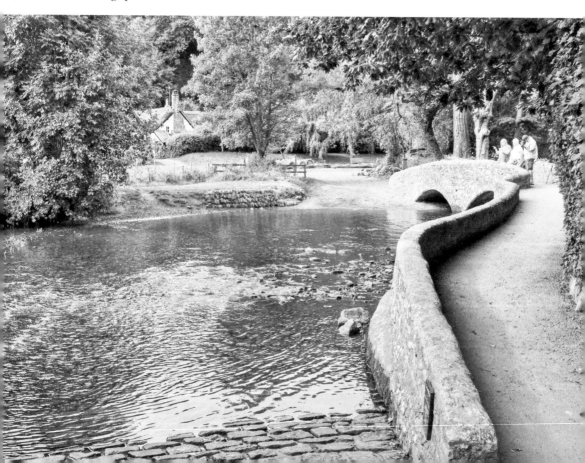

Green Spot, Minehead

While researching for this book I kept seeing references in the town council minutes to the Green Spot. Not appearing on any maps, I randomly found it while taking photographs. It is by the Jubilee Gardens, opposite the railway station, marked as such on a water pumping station that has recently been decorated by an artist from Porlock. During 2018 the area has been the site of a popular exhibition on the history of Minehead.

At the beginning of the twentieth century, town council discussions were reported in great detail, recorded word by word in the local newspaper. The Green Spot was first mentioned in 1904 in regard to public entertainments and deckchair hire. The year 1911 saw £100 set aside for the laying out of the Green Spot, which it was thought should not be turfed otherwise it would be played on and they would 'knock it to pieces'. Shrubs and a rockery were suggested. However, a great deal of debate took place about shelters, public conveniences and positioning. If they were on the Green Spot visitors would see public buildings rather than the splendid view of the sea when first leaving the railway station.

The area called Green Spot.

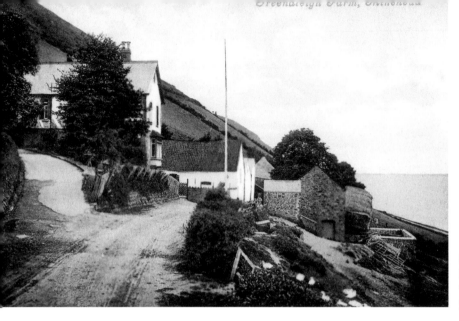

Greenaleigh Farm as it was over 100 years ago.

Greenaleigh Farm

Greenaleigh Farm was a popular walking destination for Victorian and Edwardian tourists. Part of the attraction would have been the refreshments at the farm, which was part of the Dunster estate and provided milk to the area. For many decades in the occupation of the Rawle family, adverts indicate the changing tourism side of the business – cream teas in the 1870s, campers and hot meals in the 1880s, apartments available along with luncheons to order and cream teas in the 1890s. An advert from 1924 states that it is a 'noted place for luncheons, teas, junkets, clotted cream etc.' and clotted cream could be sent by post. There is evidence of farming in the vicinity from prehistoric times and part of the original farmhouse is dated to before sixteenth century.

Gifford, Isabella

Isabella Gifford may not be well known in general circles but as an outstanding marine biologist in the nineteenth century she was noteworthy. Her work *The Marine Botanist* contained accurate and colourful drawings of 'remarkable species of sea weeds', and ran to several editions each one enlarged and improved on the earlier. She was the only surviving child of an army officer and spent her earlier years in various places, all near the sea. The family moved to Minehead in the 1850s where she became familiar with the many varieties of plant along the shores, specialising in sea weeds and making her an expert on West Somerset flora. She never married, and died twenty-four hours after her mother on 26 December 1891 aged sixty-seven, at Cranwell Villas, The Parks. Her botanical collection was given to the Somerset Archaeological and Natural History Society by her executor.

H

Harbour, Minehead

At one time it was easier to travel from Minehead to Flat Holm or Steep Holm Islands in the Bristol Channel than it was to cross land to nearby Timberscombe. The Celts used the channel as their main transport route up and down the West Somerset coastline and daily passages to Wales may have occurred as early as the sixth and seventh centuries.

Previously the small jetty was near to cottages now known as Belle Vue, formerly known as the Old Harbour House. The current quay was built in 1616 and has seen many alterations and improvements over centuries of growth, decline and necessary changes in trade. Usage has changed from being a harbour importing yarns, linens, hides, butter, lard and tallow, from Ireland, Portugal and West Africa among other far-flung destinations, to the tourist trade of more recent years. In 1703 a storm struck the country but very little damage was caused to the ships moored in Minehead, giving rise to its reputation as one of the safest ports of the day.

At one time fishing for herring was big trade but now the only fishing taking place is that of boats taking leisure fishing parties out. An information board can be found on the quayside that tells about the diverse nature to be found in the Severn Estuary.

Minehead Harbour – tide's out! Note the ancient narrow and uneven steps at the quayside.

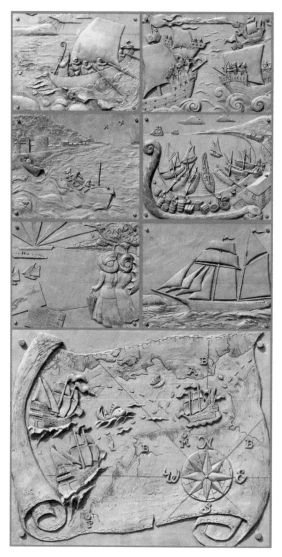

This set of plaques was designed by Sue Webber to commemorate Minehead's long maritime heritage. These were inaugurated by the mayor in 2014 at the Harbour Festival.

There are twenty-five species of sea creatures to be caught off the harbour from large conger eels to cod, plaice, flounder and bass, and to mini tompot blennys.

A set of plaques illustrate the history of the quay and harbour from earliest times to the twenty-first century.

In the Second World War, heavy guns were placed on the harbour, aimed to fire down channel. They were high enough to clear the harbour wall and disguised with buildings to look like the blockhouses on the Promenade, but they could not fire clear of the pier, so to much lament, the pier was dismantled in summer 1940. After test firing cracks appeared in the harbour wall that were quickly repaired and the instruction came to only fire if essential. However, the threat of invasion diminished and the guns were removed to other places where the need was greater.

Hawn, Dunster

Hard to believe now but at one time Dunster had a busier and bigger port than Minehead. The Hawn, which may be a corruption of The Haven, was formed by the River Avill flowing into a large pool, which then flowed through a deep channel into the sea. However, by the fifteenth century tides were causing the pool to silt up with shingle and to become shallower and Minehead became more convenient. For a time they ran side by side, with Dunster receiving heavy goods such as stone from Watchet just a few miles up the coast and slates from Cornwall. As time went on smaller boats used the port, carrying cargoes of wine, salt and wood etc., and passengers continued to come because of its pretty harbour. It was still in use when building materials were needed for the improvements to the castle.

Now it is a freshwater lake and wetland area fed by drainage from the field ditches as well as the river. Yellow flag irises, greater reedmace, sea club-rush and bulrushes can be seen in the walk around the perimeter path. During the winter migrating waterfowl make it their home, and it is an important breeding ground for several species of reed bed birds.

You may notice a rather straight and flat footbridge that was built in 1868–69 as a lockgate or sluice to create the current lake. Not only did it perform as a sluice but acted as a duck shooting bridge for guests attending the shooting and hunting parties hosted by the Luttrells. These days the whole area is part of the Dunster Beach Chalet complex.

Dunster Hawn, the shooting bridge as built for the Luttrell family.

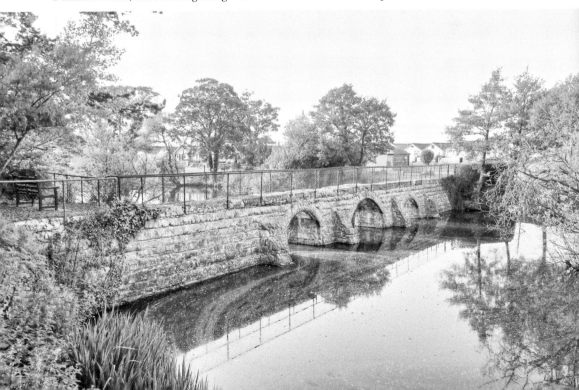

High Street, Dunster

An ancient street originally known as Chepying Street (in medieval English 'chepynge' was defined as a long market square), High Street oozes history. There have been many changes over the years. Visually the most obvious would be the removal of the Shambles in around 1825 when the original medieval market stalls, wooden huts or shambles had become too dilapidated to be safe. This area is now car parking. The adjacent Yarn Market will be described elsewhere.

Having demolished the butchers' market stalls, Mr Luttrell needed to provide an alternative market or shop from which they could trade and this was at Nos 26–28, which are now private houses and bear the date of 1825 along with the initials of Luttrell. As the 1st edition Ordnance Survey map (1844–88) shows the site as a disused market hall, it can't have been in use for too long. At one time there was a reading room upstairs and a parish hall downstairs.

No. 7 near the Castle Hotel has beams that have a recorded felling date in the mid to late 1400s. Many of the buildings are later than this, or have been altered as fashions and improved styles of living were developed. Those that are largely unaltered will have been the humble dwellings of workers unable to keep up with fashion trends, and it is these rough edges that we can now admire, appreciate and indeed marvel at when we consider the age. What tales the walls could tell if they could speak!

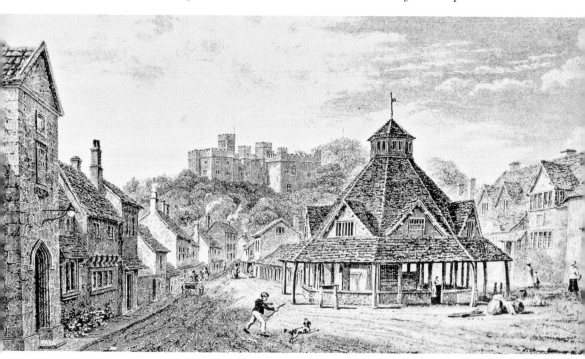

High Street, Dunster. Beyond the Yarn Market the old shambles can be seen and the Luttrell Arms is on the left.

High Street, Dunster.

Hobby Horse

The ancient Minehead custom of 'hobby horsing' involves men, historically the local sailors and fishermen, in a costume framed like an upturned boat with head through the middle disguised in a 'grotesque' mask. The tail was originally from a cow but is now made of rope. The hobby horse would then prance around the town

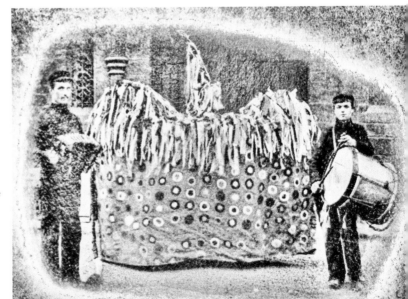

Minehead Hobby Horse as photographed by local photographer Herbert Henry Hole.

performing a variety of antics. The event begins at the Old Ship Aground on the quay on 1 May and continues for three days, with a visit to Dunster along the way. They were accompanied by 'Gullivers', who would do much of the money collecting, to such an extent they would enter people's houses uninvited. One man refused them entry, which resulted in a fracas, the injuries received ultimately leading to his death a few days later. After this the Gullivers stopped appearing (around 1863). Those refusing to pay a small fee would receive a 'booting', which appears to be an excuse to kick – or boot – a man ten times while he is being held by his arms and legs under the front of the horse, which would rise up and down over him. Hobby Horsing fell into bad favour and had all but died out by the 1890s but is happily revived again. Collected donations go to the lifeboat and other local charitable causes. Many varying stories of its origins can be found, one being that men dressed as the horse scared off Viking invaders. The other favoured story seems to be a phantom ship sailed into harbour with no captain and no crew, hence the shape representing a ship.

Holloway Street, Minehead

Holloway Street, once known as Frog Street, cuts a route up to the higher town and leads the walker on to quaint whitewashed cottages and eventually up to the parish church. The Queen's Head Inn was much altered in the late Victorian era when it doubled in size and was remodelled to its current appearance. An earlier image shows it as a very scruffy rendered building in need of much attention. The improvement was made under the ownership of the Sloman family who came from Dunster where Richard Sloman grew up in the Horse & Crook Inn. Tragically all the Sloman family seemed to die in their thirties and forties despite being admirable sportsmen. Confusingly there was also a Queen's Head on Quay Street.

A project to restore a secret garden, hidden behind a locked doorway on Holloway Street, is about to get off the ground with a survey of the former Victorian garden belonging to demolished Clanville House.

The Queen's Head Inn on Holloway.

I

Inns

Both Dunster and Minehead have their fair share of inns, alehouses and hotels. This is nothing new as back in some of the earliest records both men and women were accused of selling ale with no sign at their door or for short measures. There were strict regulations as to the brewing process and the selling of the resulting ale, and aletasters were appointed annually by the manor to ensure quality and quantity (similar to current trading standards).

One of the earliest named inns in Dunster, from around 1500, was the Wynseseller. It also boasted The Castle Tavern on High Street (1630–c. 1686), The Bell on West Street (1650s–1720s), The Swan on High Street (1680–1780), Half Moon on High Street (1639–c. 1775) and the Three Pigeons in seventeenth-century Dunster Marsh. Other names that appear in the village are Fleur de Lys, Four Acorns, Pack Saddle, Angel, Swan, White Hart or Horse, Eagle, Admiral Vernon (now part of the Luttrell Arms), Ship, Rose & Crown, Red Lion, George, White Lion, Old Castle and The Glove, which became The Horse & Crook on High Street and can still be seen with its name displayed in the very fabric of the building.

Minehead had The Key (or Quay), The Lambe, King's Arms near the harbour, New Inn, the Angel Inn, The Crooked Fish, Blue Anchor Inn, The Swan (or Three Mariners in a 1743 lease), The George, Rose & Crown, White Horse Inn, The Old Goat Alehouse on Middle Street, Red Lyon Alehouse on Quay Street, Old Salmon Inn and Royal Oak. Centrally placed, The Plume of Feathers was one of the most impressive hostelries in the town between 1686 and its demolition in 1965. A wine and spirit merchants on the corner of The Parade and Bancks Street, built by architect C. H. Sansom, later becoming a pub that still has the 'saloon bar' entrance.

A list of the hotels in 1753 included the following: Plume of Feathers, White Horse, Red Lion, Grey Hound, Star, George Inn, Nags Head, White Horse (Bampton Street), White Hart, Blue Anchor, Crooked Fish, Rose & Crown, Half Moon, Royal Oak, Old Mermaid, Three Sugarloafs, Turks Head, Kings Head, Grey Hound near the Quay, Ship, Post Boy and The Goat.

I am sure there must be more that I have missed out as names changed frequently in some cases.

Jubilee Gardens, Minehead

In 1932 plans were put forward for a bandstand in Blenheim Gardens as well as other town improvements, but it wasn't until the King's Silver Jubilee in 1935 that the first turf was cut for a sunken bandstand, and not in Blenheim Gardens but on the seafront. It was to be built by the unemployed and funds had been raised by public subscription, a permanent memorial to the jubilee. The site now comprises a very popular café and entertainment in the form of crazy golf, with each hole representing a local attraction.

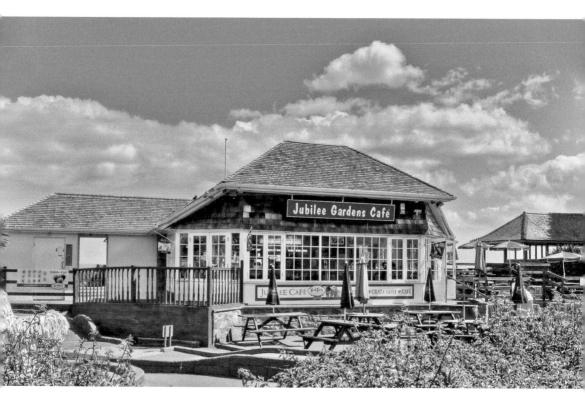

Jubilee Gardens Café.

K

Kiln, Dunster

The kiln is sat behind the Luttrell Arms Hotel and accessed from the car park by the visitor centre. It was built in 1759 and appears in a painting dated 1768. An advert in the Bristol press of January 1761 described it as 'for making the very best coarse ware'. In the same advert the brick and tile yard on Dunster Shore was mentioned. Four years later the advert was repeated. It is probably the oldest surviving pottery kiln of its type in the country and when the former potter's house was demolished in the 1850s the kiln was kept as a feature on the landscape. It was used as a gardener's shed on the Dunster estate for many years and fell into disrepair. Essential repairs restored it to its current fine condition in 2000 and 2013.

Known in Somerset as a pinnacle kiln due to its circular shape, it operated on an updraft principle for firing earthenware, fragments of which have been found on the site. Heat from the bottom would be drawn upwards, passing by the stacked pots and firing them in the process, and so drawn out of the flue at the top. Recognised as a not very fuel efficient method perhaps led to its short life as a pottery. The Luttrell tile and brickworks at Warren Point, Minehead were in operation from around 1750 and as a larger operation maybe was more cost effective. For whatever reason this pottery was not a commercial success and fell into disuse before the nineteenth century.

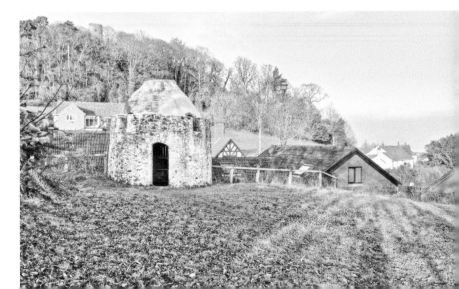

The restored
Pinnacle Kiln
at Dunster.

Lawns, Dunster

The area known as the Lawns appears on early maps and it has been suggested that the sea may have come up this high. Some of the earliest navigational maps show an estuary at Dunster, which fits with King Stephen finding the water lapping at the foot of the hill in 1138. Several centuries later maps show shooting boxes that were positioned at intervals for the hunting parties laid on for the guests visiting the Luttrell family.

The generosity of the Luttrell family has allowed public use of The Lawns, seeing it used for a variety of events – archery, football tournaments, cricket, polo, steeplechase, horse trials and tugs of war; for military reviews and parades; for fêtes, flower shows, horticultural shows and political fêtes; and for church picnics and donkey derbys.

Other than the two major annual shows held on the site, its other best-known use is as a polo ground. In 1909 the opening of a new polo ground, for the West Somerset Polo Club, with an inaugural match between West Somerset and Cheltenham took place. The ground was some 14 acres and fenced. A pavilion on the club's former ground at Allerford was removed to its new site and placed on a raised platform to provide grandstand seating to the front. The facilities met with the favour of the first Indian team, who were from Jodhpur and whose Maharajah donated a new pavilion. A second Indian team followed, this time the Maharajah of Jaipur's own team. These teams would arrive on special trains into Minehead station and stay at the Hotel Metropole. Polo ponies exercising on the beach was a common sight during this era. It was on the sands at Minehead that the first local polo match was played in 1898. The club was finally wound up in 1941 with a sale of all stock and equipment.

Leaky, Susanna

The stories about Mother Susanna Leaky vary depending on the source. From what I understand Mother Leaky had three children. Her eldest daughter, Joan, married a vicar, Dr John Atherton. Her son, Alexander, was a prosperous merchant living on the quay in the town. Her third child, daughter Susan, fell pregnant with a child reputed to be the illegitimate offspring of her brother-in-law, John Atherton. Susanna moved

to Minehead to live with her son Alexander and daughter-in-law Elizabeth. Susanna told Elizabeth that after her death 'pleasing as my company is now to you, you will not care to see and converse with me when I am dead, tho' I believe you may'. When she died in 1634 it seems she did appear to many and caused great mayhem. Reports of her giving a physick (doctor) a 'kick on the breech' for not helping her across a stile when he realised she was an apparition; of her shouting on the quayside 'A Boat, a boat, ho! A boat, a boat Ho!' and any seaman within range would be cast away whether he came to her call or not; and her own son's ships were wrecked by her blowing a whistle (to which Sir Walter Scott referred in his epic poem 'Rokeby') and causing calm waters to become stormy. By this her once affluent son lost his wealth and became poor. Worse still was the murder of Alexander and Elizabeth's only daughter, who was reputedly smothered by the apparition of her grandmother. Appearing to Elizabeth, Susanna told her she had to go to Ireland to speak to the Lord Bishop of Waterford, her brother-in-law, who had to repent for his former sin otherwise he would be hanged. The sin had been to commit adultery with Mother Leaky's daughter, who had a baby girl as a result. Said baby was 'despatched' by Mother Leaky and the now bishop. The bishop was eventually hung for sodomy. Charles I had set his privy council to investigate and they declared it a fiction, perhaps to take the focus off Bishop Atherton in Ireland.

Lifeboat, Minehead

The Lifeboat House was built following an appeal to the RNLI on land donated by the Luttrell family, and was opened in 1901. The first boat, *George Leicester*, was in service until 1927 to be replaced by *Hopwood* (1927–30) and *Arthur Lionel* (1930–39). These three were pulling and sailing lifeboats requiring a crew of fifteen oarsmen. In 1939

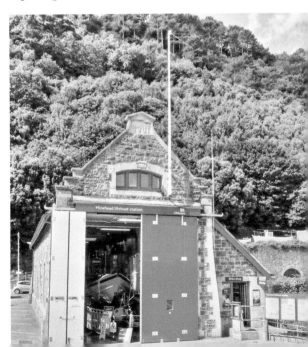

The lifeboat station at Minehead Quay.

the first motor lifeboat, the *Katie Greatorex*, was bought for £3,000, and named after its benefactor. Following the naming ceremony in July 1939 it was only a matter of two weeks before the first shout to go to the aid of a cabin cruiser on route to Ilfracombe, which had caught fire off Porlock Bay. The work of these brave volunteers continues today, much of which can be seen in the museum housed in part of the lifeboat house.

Lock's Victorian Tea Rooms, High Street, Dunster

Nestled in among other cafés and shops, it would be all too easy to miss Lock's tearooms. Down an old stone-floored passage between shop showrooms, in an old school building, you find yourself in a courtyard that then opens out to a garden. Friendly and accommodating staff serve delicious cream teas, cakes, coffees and teas. The tearooms were established here as early as 1901 when widow Harriet Lock was working as a confectioner on High Street with her adult children. In 1918 she was in the position of selling tickets for visitors to the gardens at the castle. By 1939 Edith Parsons was the café proprietor and it seems she kept the name of the original business founder, which lives on today.

A sign above the passageway records that it was formerly used as a charity school, which was established and supported by the Luttrell family around 1830 and continued to meet here until the new school building was completed in 1872.

The courtyard garden at Lock's Victorian Tea Rooms, a suntrap in winter months and a cool shady area in the heat of summer.

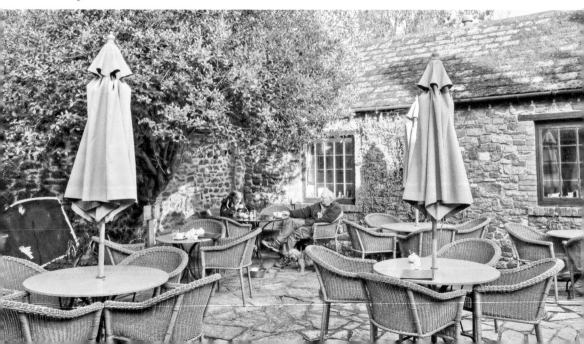

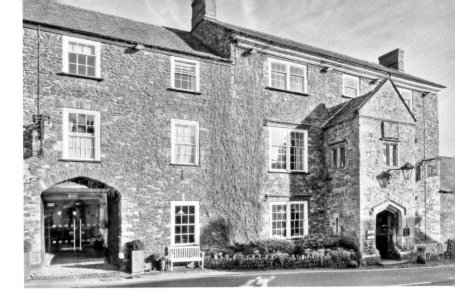

The Luttrell Arms at the top of Dunster High Street.

Luttrell Arms, High Street, Dunster

This ancient hostelry is thought to date back to the fifteenth century when it may have been the residence of the Abbots of Cleeve. Many alterations have taken place over the centuries but the front porch and internal features are of particular note, especially a carved oak window panel spanning two stories. During the Civil War, Parliamentarian Colonel Robert Blake from Bridgwater used it as his headquarters, it being known as The Ship Inn at the time.

Landlords have included William Payne (1836–1840s); John Withycombe (1866–78); Luiza Cruwys (1881); Mrs Widlake (1890); and Mr William Evered (1890–1919). When the inn was sold in August 1950 it went for £25,500 and was described as 'one of the most historic post houses in the world'. A post house is described as an inn where horses were kept and available for hire by travellers.

Luttrell Family

The Luttrell family were one of the great landed families and had property at Irnham in Lincolnshire, and they also had connections through marriage with the Paganel family. I mention this as these two names appear as street names in Minehead. Lady Elizabeth Luttrell had bought the reversion of the barony and manor of Dunster off the de Mohun family in 1375 and her son Hugh was the first to live at Dunster Castle in 1406. Hugh served the king, to whom he was related, in many capacities. His heir was son Sir John Luttrell, who died the following year, leaving one son in his minority, James. Through many generations the Luttrells served the king or queen in high position both in the country and in Somerset. George, who inherited in 1593, was noted for his hospitality and extended the buildings of the castle and was responsible for the building of the Yarn Market.

Colonel Francis Luttrell (1659–90) and his wife Mary Tregonwell lived a lavish lifestyle and accrued great debt, which was called in a few years after Francis' death. Mary then married Jacob Bancks.

The direct ancestral line died out and the estates passed to Alexander, uncle to the last surviving male heir (Tregonwell, 1683–1706, son of Francis and Mary). Alexander was MP for the borough of Minehead and married to Dorothy, who survived him. Their son Alexander inherited but died himself with only a female heir: Margaret (b. 1726). Dorothy was responsible for clearing much of her late brother-in-law's debt and also for many changes around the castle.

Margaret married Henry Fownes who assumed the name Luttrell and he eventually set about getting the estate finances in order, then buying up property in Dunster, landscaping the grounds and remodelling the property.

John Fownes Luttrell (1752–1816) and his son of the same name were both MPs for the borough of Minehead. John Jnr died without issue and his brother Henry Fownes Luttrell (1790–1867) succeeded to the seat. He died without marrying and was succeeded by his nephew George Fownes Luttrell (b. 1826), son of Francis Fownes Luttrell. He made many changes to both the castle and church at Dunster, and in Minehead.

George was followed by Alexander, then Geoffrey. The last Luttrell at Dunster before the castle was handed over to the National Trust was Colonel Sir Walter (1920–2007).

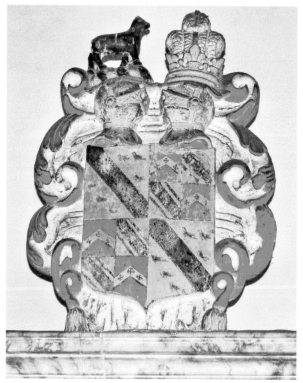

The heraldic arms of this branch of the Luttrell family that is above the tomb in St George's Church, Dunster. Luttrell arms are, simply put, combined with Hadley and Durborough.

M

Madbrain Sands, Minehead

There are several points of interest at this point of the bay but do note that the sands here at low tide are very dangerous and exploration should not be undertaken by visitors. In 1923 an old inhabitant of Minehead told a news reporter that he thought the name arose from anyone trying to walk across would be mad-brained due to the changing nature of the sand/mud! There is a submerged forest in which ancient stone tools were found. Two hundred years ago when John Collinson wrote his *History of Somerset* the roots of these trees were still visible about 4 or 5 inches above the sand. Semi-fossilised shells and oak leaves could be seen in the split fabric of the wood. The medieval fish weirs are still visible at certain tides.

A wreck revealed at low tide several times in recent history is thought to be the *Bristol Packet*, which was wrecked at Minehead in February 1808. Archaeological investigation gave it an age post-1780. The *Morning Advertiser* of 17 February 1808 reported: 'The *Bristol Packet*, "Day", from Teignmouth to Bristol, is lost at Minehead.'

On Madbrain Sands the skeleton of a wreck seen at low tide. On the horizon are the islands of Flatholm and Steepholm plus one of the many ships that still travel up and down the estuary on their way to Cardiff or Bristol.

She was an American ship and had been used for transatlantic trade visiting Philadelphia, New York, Norfolk (America) and Liverpool as well as Bristol and Teignmouth. Goods included tobacco and baled goods – presumably cloth. In January 1807 she was captured by a Spanish privateer, retaken by the 'Nile', an armed lugger in His Majesty's Service, in February and then sent into Falmouth.

Market House Lane, Minehead

Market House Lane, a small side street off The Parade, is at the heart of the town.

The almshouses were built around 1630 to form eleven dwellings. Local merchant Robert Quirke was the founder and this is commemorated with a plaque on the front wall. The bequest was funded by the cellars he built on the quay, with the annual rents paying for the upkeep. The cottages have been altered and now form eight homes. Collinson's history refers to the almshouses as facing the old marketplace.

Further evidence of the original market site is tucked in the corner. An old cross that you could overlook sits on its medieval octagonal plinth – a 1637 deed refers to a cross set in the marketplace.

Above: Market House Lane almshouses.

Left: The Market Cross, Market House Lane. The almshouses are to the right.

The original plaque commemorating the founder of the almshouses and the 1986 restoration.

Marsh, Dunster

As the name suggests Dunster Marsh would have been a marshy area and there are records that show in the early seventeenth century attempts to dam the sea by Luttrell's architect, William Arnold, failed as saltwater kept flooding the land. During the eighteenth and nineteenth centuries systematic reclamation of the marshes took place and much of this land is now taken up with Butlin's.

Lower Marsh Farm, and what is now called the Old Manor House, originate from the fifteenth century. While the farm exists as a dairy farm, the Old Manor House is a substantial holiday let and displays many of the original features of such an ancient building. The farmer of Higher Marsh Farm had a water-powered threshing machine installed in 1810, which proved to be a good money spinner. When his tenancy ended he tried unsuccessfully to remove it and he found himself prosecuted for his troubles. The next tenant of Higher Marsh also farmed Priory Farm in Dunster and successfully ran the two. The farm site has now been redeveloped into a modern housing estate.

Marsh Street had a few sixteenth-century sandstone and cob cottages along the lane linking the sea and the main village of Dunster with some twentieth-century infill. At the top of the lane is the former Victorian police station, which was in use until the Minehead and Dunster stations merged in the 1930s.

The war memorial on Martlet Road.

Martlet Road, Minehead

The outstanding feature along this road, other than the spectacular views glimpsed between the houses, is the war memorial. Constructed in 1921 to commemorate the 104 fallen in the First World War, fifty-four were added around the plinth following the Second World War. The view is somewhat changed from 1921 but the sentiment on Remembrance Sunday doesn't change as we remember those who sacrificed so much not just in the First and Second World Wars but in other conflicts since.

Mill Lane, Dunster

At the top end of Mill Lane is the former Wesleyan Day School and Master's House. Founded by William Moore, after nearly 100 years it closed in 1903 due to falling numbers. It was receiving pupils by 1825 and expanded in 1839 due to demand. Perhaps this was aided by a legacy left in 1831 by Miss Priscilla Moore, aunt of William, towards the Weslyan School at Dunster. One hundred and sixty children attended an annual school treat to Dunster Beach in 1860. In 1874 after a closure, reopening was advertised in the press with places for boarders. A plaque on the front of the old school acknowledges the former use as it is now a private house. There is another plaque dated 2 September 1811 and the bible verse 'Then Samuel took a stone and set

Right: Mill Lane, Dunster, with the former school on the left.

Below: The mill leat runs down a channel at the side of Mill Lane before reaching the watermill at the end of the lane.

it up between Mizpah and Shen. He named it Ebenezer, saying, "Thus far the Lord has helped us" 1 Samuel chapter 7 verse 12'. Further down the lane is the Water Mill Tea Room, a cafe and gift shop, in former stables and cart house with its neighbouring Castle Water Mill.

(De) Mohun Family

William de Mohun, one of the knights supporting William the Conquerer in 1066, built the castle at Dunster having been given sixty-eight manors mainly within Somerset including Minehead, East Myne (on North Hill), Bratton and Alcombe, as well as Dunster. The family held their property for 300 years and achieved many titles over this time – Sheriff of Somerset, crusader, Earl of Somerset and baron. One William earned the name 'Scourge of the West' through his plundering and burning of property in the region. Reginald de Mohun II was responsible for the establishing of the annual fair and weekly market, obtaining the rights from Henry III. The last de Mohun to own Dunster was John (1320–1375), an experienced soldier who fought at the Battle of Crécy and was one of the first recipients of the Order of the Garter. His widow Joan, having no male heir, sold the right of succession to Lady Elizabeth Luttrell for 5,000 marks on 20 November 1377 while retaining a life interest, and thus the manor passed into the hands of the Luttrell family.

The tile floor in the chantry chapel of St George's Church uses some heraldic designs including those of the de Mohun family.

N

North Hill, Minehead

North Hill encompasses a large area of both town and countryside. In 1883 George F. Luttrell built a carriage drive around the hill and today more walks with spectacular views can be enjoyed. These include part of the South West Coast Path, walks to Burgundy Chapel, Greenaleigh Farm and to Selworthy parish.

Within the town the North Hill building estate was offering twenty-five building plots for sale by auction in 1900. The Minehead Land Company who owned the land had laid out the roads and services, and divided plots suitable for a detached or a pair of semi-detached houses. Conditions were such that any building had to have taken place within three years and the properties built had to attain a certain value for rental purposes, therefore keeping the quality high. The lowest price attained for a plot was £10 and the most expensive £41. Purchasers came not just from Minehead but from London and Cardiff, a steamboat, *Lady Margaret*, having been laid on especially for those intending to buy.

North Hill, Minehead, photographed in 1901 before mass development, and before the tree plantations had been established.

Another activity that has taken place on this beauty spot has been army training exercises with frequent camps of assorted volunteer brigades. During the Second World War the hill was closed to civilians when it became one of five tank training ranges – concrete bases can still be seen. Hidden away, another secret of the hill was the former radar station that was one of a total of 244 across the country.

Nunnery, Church Street, Dunster

The Nunnery is on Church Street and of a very early date with timbers dating to the fifteenth century. Hugh Pero (or Pyrou) of Cutcombe gave the site to the abbot and Convent of Cleeve in the previous century and the monks may have built this building soon after. After the Dissolution of the Monasteries it was passed to Robert Quirke of Minehead. Of stone construction, and externally hung with slate tiles, it is a noticeably different type of building to its neighbours. At times it has been known as the High House and the Tenement of St Lawrence. An advert for its sale in 1825 refers to it as a 'malt house ... called The Nunnery, lately occupied by Mr Robert Harvey now vacant'.

The Nunnery, Dunster, as depicted by historian Maxwell-Lyte.

O

Old Ship Aground, Minehead

Formerly known as the Pier Hotel, the current building dates to the 1880s when the older, original building was rebuilt. Further alterations in 1908 included a new excursion bar with refreshment room above. An advert in 1905 promoted a 'smoking concert' given by the local West Somerset Conservative Unionist Association. 'Smoking concerts' were performances usually for just men, where smoking was allowed. Now, it's still a hotel and bar, with a restaurant offering the best of local produce.

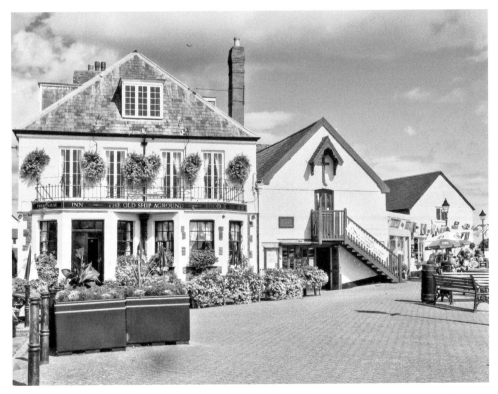

The Old Ship Aground and St Peter's Church, which is in one of the former cellars belonging to the Quirke family.

Parade, Minehead

The Parade forms a short section of road through the current heart of Minehead and forms the main shopping area. It was originally known as Puddle Street, a name which was descriptive with good reason as the Bratton stream flowed down a short section of it before joining the sea near to Blenheim Road. Substantial improvements throughout the nineteenth century resulted in the road seen today with its selection of shops, cafés, banks and other businesses.

On both sides of the road there are buildings designed by architect St Aubyn, who is responsible for so much of the architecture in the town. The current TSB building

View of The Parade showing the Market House with its cupola and weathervane.

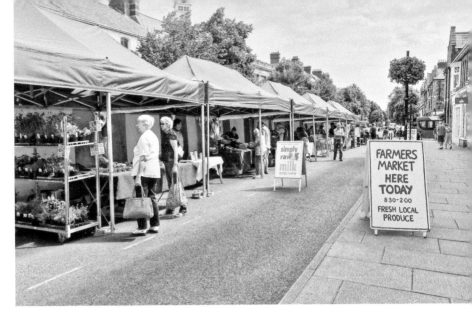

Minehead's weekly farmers' market.

intrigued me; look up to between the first and second floors and there are carved heads of different people. Are these notable locals, the then owners of the bank (Devon and Cornwall Bank until absorbed into Lloyds in 1906), or other local people? In 1930, as Lloyds had absorbed Fox, Fowler and Co. on Park Street a few years earlier, they enlarged the bank on The Parade before closing the smaller premises. Before the current building was erected the site had housed the Lorna Doone Temperance Hotel.

Another notable building along here is the Market House, also known as the Town Hall. This was designed in 1902 by local architect W. J. Tamlyn and has an attractive cupola with a clock. The market was historically always held in the vicinity of the current building. The current farmers' market is held along the other side of the road every Friday morning, continuing a long tradition.

A third long standing business along this stretch is Toucan Wholefoods (established 1982) and café (established 2010). Venture upstairs for refreshments and to admire the art exhibition on display in one of the four rooms. Some of this book was written in this very café!

Park Street, Dunster

Leading from the A396 down towards Gallox Bridge, you may at first think Park Street is another lane with small terraced cottages, but as you reach the middle, a view of perfect English country cottage scenery greets you. A scene so lovely it has appeared on biscuit tins and chocolate boxes. Riverside, Brook, Old Steam and Rose Cottages date from the seventeenth century and wouldn't have always been as picturesque as today but would have been homes for the workers. In the nineteenth century they housed some of the poorest families in Dunster. At one time the lane was known as Water Street, another clue as to their former condition perhaps as has been seen with other street names in this volume.

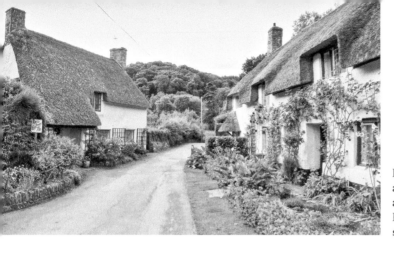

Park Street, Dunster, according to archaeologists from 'The Big Dig' team, may have a slightly seedier past!

Park Street, Minehead

Park Street was formerly gardens and the tithe map from the 1840s shows higgledy-piggledy houses with gardens. With the front facing Wellington Square is the HSBC bank, the building dating to approximately 1850 and which used to be a house with shops. Also along the street have been Coxes Bazaar, later with circulating library, Treweeke & Sons, and W. Bagley's hairdressers, which was offering to make ladies combings into tails – presumably hair brushings into pony tails but whether for the 'owner' or another is not clear!

Parks, Minehead

Leading on from Park Street is The Parks, a rather nice, mainly residential area of town. Continued development of villa residences benefited from the arrival of the railway following on from late Georgian and early Victorian development already there. The properties indicate a level of prosperity already prevalent in the town before the seaside boom took off. The Baptist Chapel is dated to around 1821 with enlargements in 1901/2, and again in the 1980s. The former ministers house next door is dated to 1931.

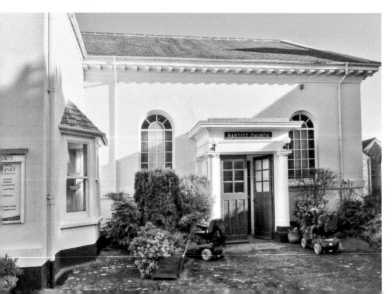

Minehead Baptist Church entrance, situated on The Parks.

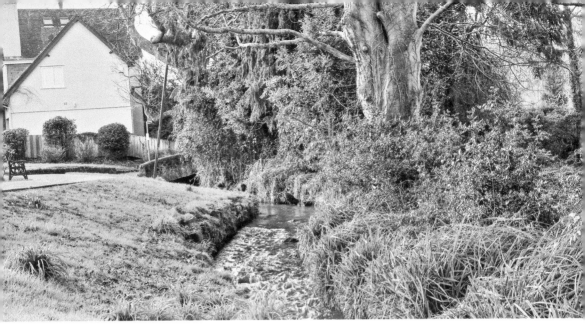

The start of the Parks Walks from Parkhouse Road.

Parks Walk, Minehead

In 1926 a proposal was made to purchase land for the purpose of creating a public garden walk through the Parks Valley to Bratton. It had one aim, which was to create open spaces away from the increasing noise in the growing town. The start was just beyond the then post office on Parkhouse Road, and it was to follow the line of the stream up to Bratton village. Suitable planting schemes for protection from the sun and wind, with seating areas, was proposed, and with some vistas to be kept open to ensure the views to Woodcombe Brake and The Ball could still be enjoyed. Tropical planting was suggested to emphasise the mild climate in this area of Somerset. The walk is still open but the views have since disappeared behind building works done since the initial planning stages nearly 100 years ago.

Pier

For a seaside town the Promenade Pier was very short-lived. Building started for the Minehead Pier Company in 1899 at a cost of £12,000 and the 700-foot-long pier opened in 1901. It had four landing stages at different levels to take differing tide heights and was soon offering daily trips to Cardiff, with Ilfracombe and other north Devon resorts several times a week. Campbell's White Funnel Fleet ran steamships during the early years. Entertainments also took place on the pier for which a pier admission fee of 6d was due – The Military Mummers, a costume concert party, appeared during the 1909 season. Although the main structure is long gone, the concrete bases remain and can be seen at low tide near to the lifeboat station.

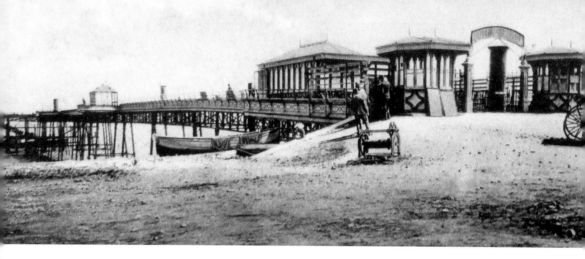

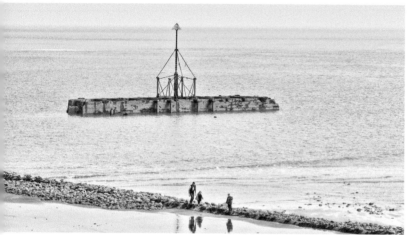

Above: Minehead Pier as depicted on an old picture postcard.

Left: These concrete supports are all that remain of the pier.

Pirates and Privateers

A pirate is described as one acting against the law while a privateer is licensed to attack foreign shipping if at war with that country. In 1627 the Bristol Channel was populated by many pirate ships and two privateers, the *Elizabeth* and the *James*, were both licensed to attack. Prizes were brought into the harbour at Minehead from near and far and goods unloaded. A hundred years later three Minehead ships were licensed as privateers and these were *Three Brothers*, *Wincanton* and *Queen Anne*, all of which were fitted out for a lengthy stay at sea. One privateer, the *Dove*, was captured by the Dutch while not at war, which then sank with the loss of three lives and all its goods that had been captured from the Portuguese. Valued at over £20,000, today this would be over £2.5 million.

Richard Sare was a pirate from Minehead about 1534 and described as a notorious evildoer. He was acquitted when tried in Exeter but then had to seek sanctuary at Westminster where he described his adventures at land and sea. Regrettably no more is known about him.

Q

Quay West and Area, Minehead

Now primarily focussed on tourism, this was once a hive of activity as a business area. Warehouses were here aplenty, as were the inns – The Red Lion, Star, Kings Arms, and The Lamb – no doubt offering relaxation for the sailors visiting port. Now pretty cottages, dating from as early as the seventeenth century, nestle against the hillside with their steep gardens, which must be a challenge for any gardener. Look out for some surprising artefacts hidden among the plants. At one time there were

Cottages along Quay West.

cottages between these buildings and the sea but many were partially destroyed when a storm demolished the quay wall during a high tide. In October 1859 it was reported that every fishing boat in the harbour was destroyed, which it was thought would result in much hardship as the herring season was due. It was this that provided winter income for the townspeople.

Quirke Family of Minehead

A Minehead family for more than 200 years, the Quirkes first appear as being in debt but eventually rose to become one of the wealthiest families in the town, holding the position of town burgesses and becoming benefactors. Robert Quirke had the almshouses built in 1630 following a near-death experience while at sea. Two cellars near the quay were, on his death, to be let to provide funding for the maintenance of these almshouses. A brass monument commemorates the family in the parish church while painted boards with the Twelve Commandments and the Articles of Faith were donated by other members of the family and can also be seen in St Michael's Church.

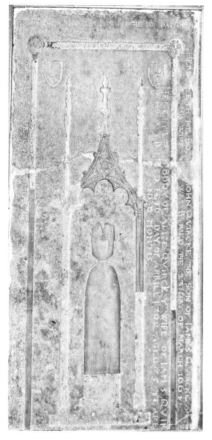

The Quirke family brass memorial situated in the floor of St Michael's Church.

R

Railway

Today the West Somerset Railway is one of the most successful private leisure railways in the country. Passing through wonderful Somerset countryside from Bishop's Lydeard to Minehead with many stops along the way, including Dunster Marsh, one must wonder why it was ever closed in 1971.

The turntable was installed at Minehead station in 2008 and here steam locomotive 7820 *Dinmore Manor* is being turned.

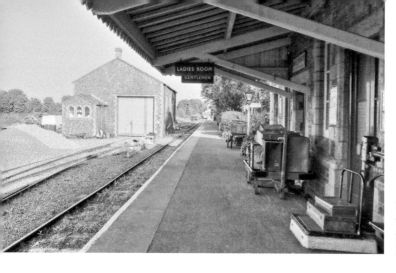

Dunster railway station would once have received the guests staying at Dunster Castle.

The growth of Minehead as a seaside resort can be attributed largely to the advent of this line back in the 1870s. Population figures rose steadily in the town once people had access to and from Taunton, which was the start of the line. Tourism really began to take off leading to development of the associated services, which required staffing, and staff who then required somewhere to live. The first sods of earth were cut in December 1871 with the aim of opening the line by the end of the following year when it would be leased to the Bristol and Exeter Rail Company. The local newspapers reported on the first trains from Watchet to Minehead in July 1874 when great celebrations were had with special teas for the children, banners adorning the town and proclaiming success to the railway.

Initial journey times from London Paddington were not speedy, taking nearly seven hours. A further extension of the line from Minehead to Lynmouth and then onto Barnstaple was proposed in the 1890s but never materialised.

The stations at Dunster and Minehead were built to be ready for the opening of the line. John Pearse built Minehead station at a cost of over £1,118. Extensions were made as the demand grew including a platform extension in 1933 making it a quarter of a mile long.

Dunster station was built by William Harrison & Son for £912 and was in a slightly grander style as it was expected to be used by the Luttrell family and their guests at the castle.

The railway was closed in 1971, but thanks to a group of enthusiastic people, the West Somerset Railway Company was formed within months and from 1974 they have gradually reopened stretches of the line to make the successful attraction that so many enjoy today. The most famous travellers were probably The Beatles, who visited the town to record part of their first film on location in March 1964. Sixteen boys held up a banner stating 'Your empire is crumblin', Viva Brahms'. With 500 girls in support of the band the boys' banner didn't stand a chance and was trodden into a nearby ditch. The girls were in return saluted by the fab four with glasses of champagne. However, one little girl was sad to miss them arrive, so revisiting the following day, The Beatles had been told how upset she was, and spent some time with her on the platform before the filming restarted.

S

St Andrew's Church, Wellington Square, Minehead

It was recognised that the way to the parish church on North Hill was steep, resulting in the building of St Andrew's on ground given by the Luttrells. Architect G. E. Street designed the building in a 'Free' Gothic Revival style, built from local Staunton quarry sandstone with dressings in Doulting stone, a natural stone from another local Somerset quarry. The aim was to seat 324 worshippers. The project was funded by Charlotte Luttrell, the wife of Revd Alexander Henry Fownes Luttrell, vicar of Minehead church and cousin of George Fownes Luttrell who gave the land, causing the church to be referred to as the Luttrell Memorial Church on occasion. The medieval-style east window of 1888 is a memorial to Revd Henry Luttrell, who died in 1899. In 2004 a two-storey annex was built providing offices and meeting rooms.

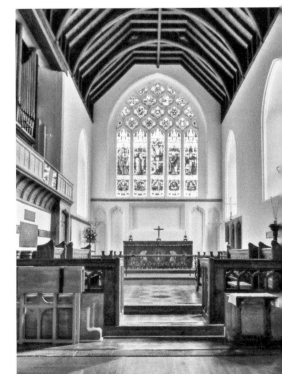

The interior of St Andrew's Church showing the impressive east window.

St George's Church, Dunster

The church was in existence when William de Mohun took up the manor in 1090 and he gave it to the priory at Bath, leading to the eventual formation of the priory in Dunster, although this may not have been for a couple of hundred years. The Benedictine priory was a cell of the monks of Bath Priory (a cell in this context is a small dependent house of a major monastery, sometimes of only a few monks).

A series of disputes during the 1490s led to the division of the church, one half for the monks led by the prior, and the other half for the parish led by the vicar. At the dissolution in 1539 the priory was given to the Luttrells, who used it mainly as a mausoleum and finally gave it to the parish in 1990.

The resulting influence of the priory is left in the village with the priors house, which was remodelled in both the sixteenth and nineteenth centuries, together with the cloister gardens, the priory dovecote and the tithe barn.

The church building was restored in 1875 by G. E. Street, some of which did not meet with approval; for example the removal of plaster and monuments. Thankfully he left the wonderful rood screen, which is from 1499 and may be the longest fan vaulted rood screen in the world. At one time this would have been painted in bright, vibrant colours. Around 1800 the then parson, Revd Lee, had it whitewashed and if you look carefully traces of paint can be seen in the intricate carving. The waggon roof is of the same date but the south aisle roof is even earlier, around 1450.

The Priory Church of St George, Dunster.

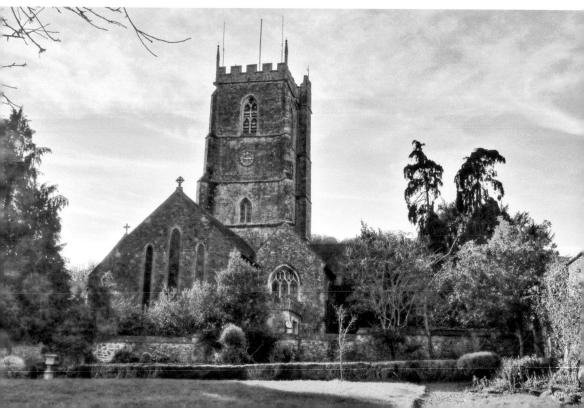

Above: The exceptionally fine rood screen of St George's Church, Dunster.

Right: The Cloister Garden tucked around the back of St George's Church – a haven of peace and quiet.

St Michael's Church, Minehead

The parish church of St Michael is a prominent feature on North Hill and at one time was the building that would have been visible from out at sea. In the days before electric lighting and street lamps a burning light in the loft, which was used to guide fishermen in the Bristol Channel, would be quite a striking feature or warning. The dedication of St Michael was popular among the seafaring Celts.

There are some very old features to look out for: the fourteenth-century south door arch; the font dated around 1400; a 1487 sculpture of St Michael weighing souls; the 1529 east window above the altar; the sixteenth-century rood screen; the seventeenth-century carved pulpit; numerous memorials both in brass and stone; and effigies from as early as the fifteenth century. Wooden painted boards with the Ten Commandments and Articles of Faith, dated 1634 and 1637, were given to the church by Robert Quirke. The church's most precious artefact is the Fitzjames Missal, a service book that belonged to one time vicar of Minehead, Richard Fitzjames, later Bishop of London. It is thought to date to the fifteenth century but some scholars think it may be fourteenth. A figure, 'Jack Hammer', near the roof loft stairs dates to the seventeenth century and may have at one time struck the church clock.

There are no features prior to the fourteenth century but it is understood that these were added to an earlier structure. More modern restoration in 1886 was overseen by St Aubyn who removed the then current pews and stone floor as well as replacing the roof structure with the current one. Further restorative works took place in 1974.

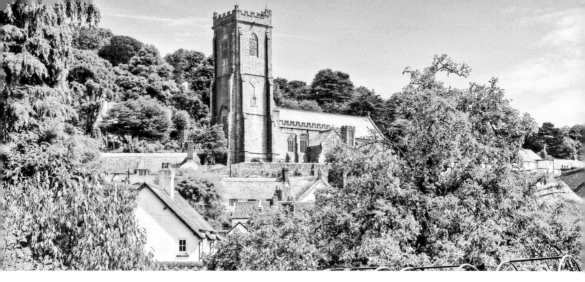

Above: St Michael's Church taken from the former vicarage garden.

Left: St Michael's Church interior showing the east window, the rood screen and 'Jack Hammer' perched on top.

One quaint local custom that was observed in Victorian times was the barring of the church gateway for a newly wed bride and groom. On payment of a toll the couple would be allowed over the rope, which was decorated with greenery. There would then be a second rope barrier to pass over. One church clerk knew it as a very old custom but one not performed elsewhere to the best of his knowledge.

St Peter's Chapel on the Quay, Minehead

This chapel was formed from one of Robert Quirke's two cellars, when the church leased the property to use as a mission to seamen with a reading room upstairs in December 1905. Known as the Gibraltar Cellar, its survival was due to the income raised for the upkeep of Quirke's almshouses while all around was being redeveloped. The dedication to St Peter was made in March 1906 by Revd Etherington, following

The interior of St Peter's, the fisherman's church.

extensive repair and conversion. A full report appeared in the local newspaper of 31 March. In 1970 the parish finally bought the property. The panel 'God Speed the Ship' commemorates those who died in the two world wars.

St George's Street, Dunster

St George's Street is a good example of ribbon development. Seventeenth-century thatched cottages are near to the Church of St George while Victorian villas are further away as the village expanded.

St George's Street, Dunster.

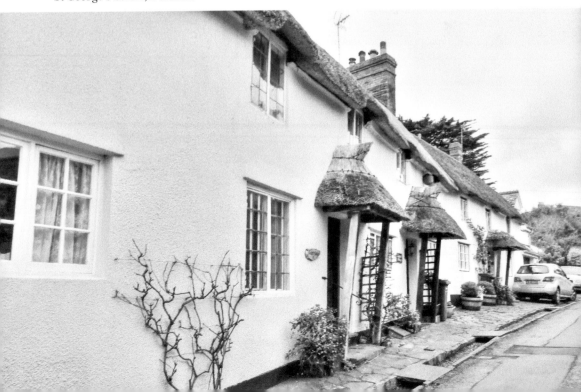

The Butter Cross is late fourteenth century and used to be at the foot of Castle Hill, on the junction with High Street. It was moved to its current location around 1820. It could have been either a wayside cross or a market cross.

The village school, designed by architect St Aubyn and built in 1871 by local builder C. H. Samson, opened in 1872. Still in use today, although with some modifications to meet modern need, the school caters for pupils from reception to year four.

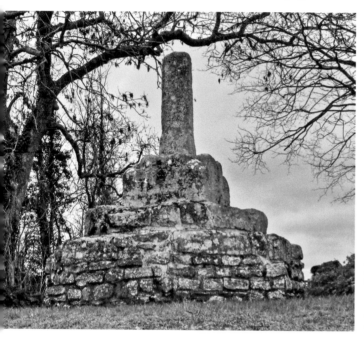

Left: The Butter Cross, Dunster, situated on the edge of the village.

Below: Dunster First School viewed from the churchyard.

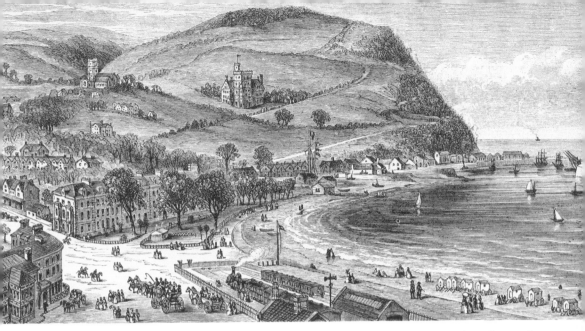

Minehead bay as depicted in *Where to Buy in Yeovil*, 1891. Bathing machines line the sand while on North Hill Elgin Tower is the only mansion.

Sea Bathing

A directory of 1790 made mention of the persons of quality who had visited Minehead for its safe sea bathing and the 'salubrity of the air'. Just a decade later Revd Richard Warner of Bath recognised that despite the town having lost most of its trade from imports and exports, it was still visited during the summer months for bathing where the bathing machines were commodious. Accommodation was cheap, maybe because it wasn't as easily accessible as some other resorts. A new turnpike road opened it up to more people but it was still quiet compared to other resorts. In the 1860s Alcombe School was particularly keen to emphasise in their adverts that the boys were taken to Minehead for the sea bathing.

Selbourne Place, Minehead

At the top of Friday Street is Selbourne Place, formerly known as the Butts. Along here is a convent founded by the Sisters of Charity of St Louis, who arrived from Vannes, France, in 1898. The original building bought and converted for use as a school was opened in August 1900. Private French lessons were also offered, maybe to supplement income to support the orphans, for the convent was able to home sixty girls. There was a reverend mother and sixteen sisters. When they reached the age of fourteen the girls were put to work in the laundry, which was in the grounds. Alterations and building work over the next few years saw the convent with a farm, a top-floor chapel and a library as well as the usual reception and bedrooms.

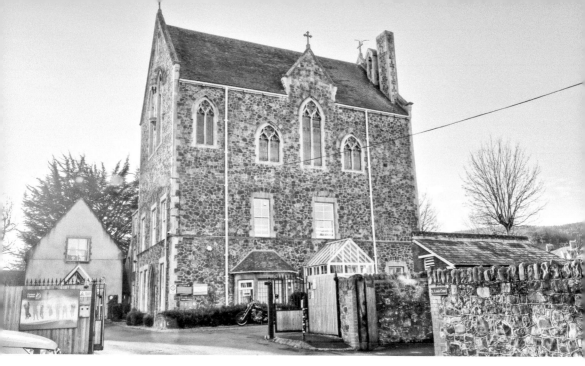

The former convent on Selbourne Place with fine chapel windows on the upper floor.

In 1926 St Teresa's Convent School was opened in the grounds adjoining the convent. In 1937 it would have cost thirty-three guineas a term. The school remained open until 1994 when it was converted into Minehead First School. The former convent building is now part of Foxes Academy.

Smuggling

Due to the obvious secret nature of this 'pastime' very few records survive. However, in 1682 when William Culliforde, Surveyor General of Customs for Charles II, was sent to inspect the port he found much evidence of contraband. It was reported that a ship named *Swallow* had berthed and under cover of darkness part of the cargo – wine and brandy – was taken to the cellar of Thomas Wilson, one of the ship's owners. For the following four nights Mr Hooker's wagon from Taunton took the goods away. A local constable had actually been employed in removing the goods from the ship. Tidesmen – officials stationed on board to ensure nothing was smuggled ashore – were also involved and it was thought that all the customs officers at Minehead were implicated. Goods included hogsheads of wine, casks of brandy, Irish frieze (a linen cloth) and packs of cloth. When local shoemaker Peter Bond spoke out against the smugglers a merchant went to Colonel Luttrell and had Bond thrown into prison. As a punishment Bond received 100 lashes or more (no man in Minehead would administer this punishment, perhaps an admission of guilt, so Luttrell sent a man from Dunster Castle to perform the task).

In the nineteenth century the Minehead Coastguard Officer found large quantities of contraband at Greenaleigh Farm.

T

Tithe Barn, Dunster

This building was originally part of the Priory of Dunster for receiving and storing the tithes of the parishioners – tithes were 10 percent of the harvest to the church, a custom in place since the seventh century and finally abolished in 1966. From the 1830s payment was commuted into financial giving. This building has its origins in the sixteenth century, being added to and repaired over the centuries. It was finally restored under the guidance and enthusiasm of a team of committed local people between 2002 and 2007, having been given to the community by the Crown estate. Now it is a beautiful heritage building made fit for twenty-first-century use.

Dunster Tithe Barn.

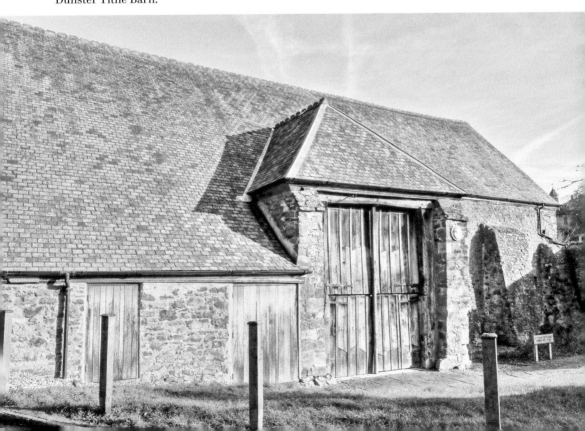

Townsend Road, Minehead

There are several prominent buildings along this road, making a stroll worth your while. The first is Townsend House on the corner with Selbourne Place. This was once the home of Richard Cox, a maltster and a political agent for the Luttrell family who owned the property. It is thought that the building dates back as far as the sixteenth century. Not much of this remains now, the original having been greatly altered over the centuries – surely a sign of the wealth of those living there. A green plaque by the door outlines the following points: that it was first recorded in 1456, rebuilt and then remodelled, the home of the Red Cap School in 1900 and an air-raid warden shelter in the Second World War.

Next is the Roman Catholic Church of the Sacred Heart, built in 1896 by church architect Canon A. J. Scoles. The first Catholic place of worship in Minehead was on Selbourne Place in a rented building during 1891. A plot of land was purchased by the diocese of Clifton from the Luttrell family, and funding by subscription enabled the current building to be erected. Within a short space of time, an extension and alteration was needed as the church proved too small for the visitors during the summer months.

The Kildare Lodge Inn was built in 1907, an Arts and Crafts house built by Barry Parker in the style of Lutyens. It was built for local doctor Gordon Henry, who was then living at Blair Lodge. The house was to have waiting and consulting rooms each side of the front door, complete with stabling and associated services. All that an up-and-coming doctor could wish for. He even had the polo team in which he played named after his house. It is now a hotel and restaurant.

The final building of note on this stretch of road is the police station and courthouse with the former superintendent's house. Again the land came from the Luttrell family

Townsend House, Minehead.

Above: Sacred Hearts Roman Catholic Church.

Below: Kildare House, a beautiful Arts and Crafts building.

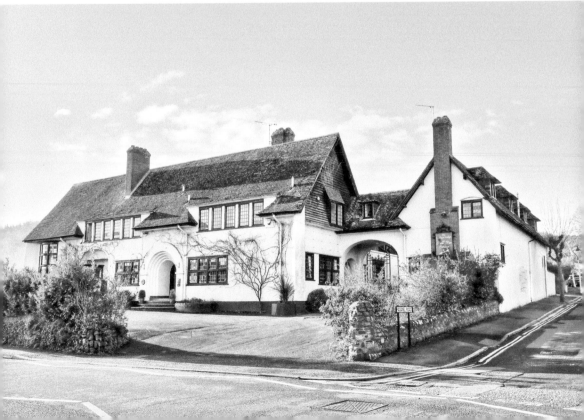

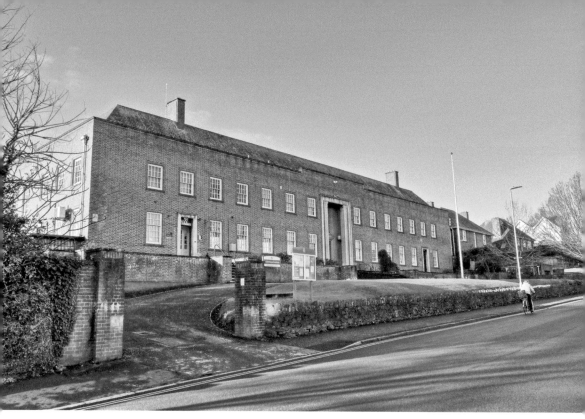

Minehead police station and court built in the 1930s, with the former superintendent's house visible just beyond.

with plans proposed in the early 1930s. The station was to replace the premises on Blenheim Road and the station at Dunster. The county architect A. J. Toomer included in his plans two courtrooms, magistrates and solicitors offices, flats for police constables on the first floor, and the main police station and cells on the ground floor. There were separate male and female waiting areas and parade grounds in a courtyard, now forming the car park. Note the Somerset crest of a dragon over the front. Neighbouring the station is the former superintendent's house, which is now a private residence.

U

Underground, Dunster

At Dunster Castle you can find the unexpected underground. A dungeon, in the form of an oubliette, yes, there is one of those, but here at Dunster you can also find a reservoir. It was constructed in 1870 as part of the improvements implemented by George Fownes Luttrell in collaboration with his architect Salvin to provide a water supply to the castle, Dunster and Minehead. It holds 40,000 gallons but was finally abandoned by the Somerset Water Board in 1976, though in recent years it has been opened up to the public by the National Trust.

Vicarage Road, Minehead

On some older maps Vicarage Road is labelled Church Street and what is now Church Street, Middle Street. Both ultimately lead to the church and both form part of the historical centre of Upper or Higher Town. As the current name suggests, the former vicarage was located here, and sold by auction in 1947. Converted, it now forms two homes called 'Edgehill'. The former stables on the junction with Moor Road are still nicely enclosed within their original walling, although the stables are now a house. The impressive gateway can be admired for its grand size but when you consider the grizzly rumour that surrounds it you may not be so impressed. Apparently the

Vicarage Road and the former vicarage with stables.

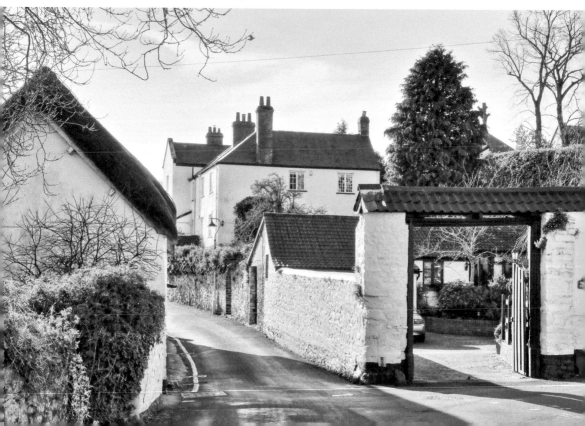

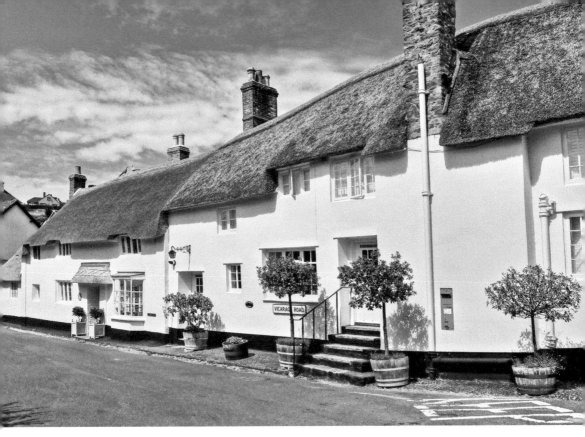

At the other end of Vicarage Road are cottages that once housed small shops.

framework was used as a gallows and the vicar, after saying the final prayers would watch the last moments of life from the vicarage windows. Firm documented evidence hasn't been located yet so this still remains rumour.

Moving closer to the church there is a most picturesque collection of thatched cottages. A former shop, a malthouse and neighbouring pub make a quaint little community now intersected by road rather than what would have been a quiet lane with an occasional horse and cart or carriage. Some of these properties date back to the 1500 and 1600s.

Warren Point, Minehead

Warren Point, almost midway between Minehead and Dunster Beach, is now the site of a well-established golf course and perhaps an easier walking area than the North Hill area of town. You can walk from here to Dunster Beach quite easily and enjoy views across the channel to Wales and up the coastline of Bridgwater Bay.

The Warren was established as a golf course in 1882 when Dr Clark, a Scotsman, arrived in the town and was seeking somewhere to play his national game. Designed originally with just nine holes, it was extended to eighteen at the end of the nineteenth century. The clubhouse, although altered and extended, started life as Warren Cottage. Newspaper columnist 'Proteus' wrote the following in the *West Somerset Free Press* when he heard of the proposed meeting to form a local club:

> I see there is a meeting advertised to be held....to get up a golf club. I was as wise as most people as to what 'golf' might be until I inquired, and found it to be a modification of the old game of hockey but with fewer players and hedged about with more numerous restrictions, the aim of the players being to get the ball into a hole in the fewest number of strokes. Whether the favourite Scotch game can be made to flourish at Minehead remains to be seen. I shall do it no harm, at any rate, if I wish it success.

The meeting was held and it was unanimously agreed that Minehead should have a club on ground rented from Mr Smith of Warren House and so the Minehead and West Somerset Golf Club was born. There were only six in England at this time so it was going to be a boon to the local tourist industry.

On 30 June 1941 a British Spitfire came down on the golf links, and while the plane was damaged the pilot was unhurt. Just under a year later on 8 April, another Spitfire came down but this time the plane was wrecked and the pilot injured.

Long since gone are the brickworks, which were founded in the mid-eighteenth century for the Luttrell estate. Bricks, tiles and pipes were produced here from clay dug out of the pits on site up until 1919. Materials created here were used to build Dunster station.

The view over the West Somerset Golf Club towards Dunster Beach and the Quantock Hills beyond.

The Luttrell estate also had the right to take sand from between the harbour and town but in 1911 was requested to stop and to only use material from Warren Point onwards. The sand was used in the maintenance of agricultural property and the subject of the lack of sand on the beaches came up at various council meetings as removal was to the detriment of the tourist trade.

Warren Road, Minehead

Warren Road stretches right along the seafront from the railway station eastwards towards Butlin's and on to the golf club. The end near to the railway is sometimes referred to as the Strand. It is wide and airy with modern sea walls on one side, entertainments along part of the other, before modern residential flats take over. These flats are built on the site of the much lamented bathing pool, which was built in 1936 and demolished in 1991 after being diagnosed with 'sick concrete disease'.

Queen's Hall was built by local company Marley Builders in 1914, to show theatre productions alternating with cinema. It was soon on the entertainment circuit, with music hall stars and theatrical performances being advertised in the local press. In 1921 an advert for touring winter shows who wanted to appear stated that the auditorium seated 750 and that they held most scenery in stock. Disaster struck in September 1922 when a fire forced closure for a couple of weeks. Following a performance of a Bernard Shaw play *You Never Can Tell* a fire on the stage did considerable damage to both the set and the stage. Since the days of the touring entertainments the venue has hosted boxing, been a nightclub, screened major sports matches via a big screen and now awaits a new lease of life.

Warren Road with the once grand Queen's Hall at the far end.

Wellington Square, Minehead

Before St Andrew's Church was built Wellington Square was a much larger area of open space and was part of the property known as the Wellington Inn. From the map of properties burnt during the fire of 1791 it looks as though a former building on this site may have been destroyed.

Wellington Square with the annual Christmas tree in front of St Andrew's Church.

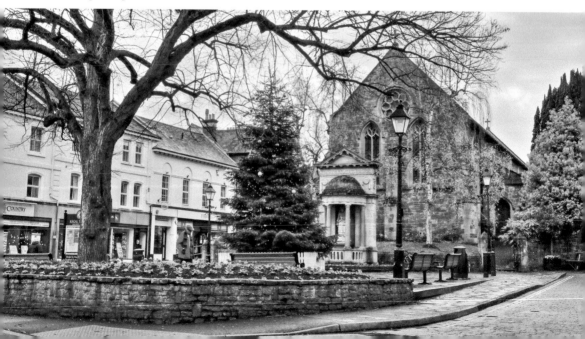

The inn was built in the 1820s and soon became a popular coaching house, along with the Plume of Feathers on another side of the square. Accommodation for tourists was offered and the 'Pilot', a coach run by Burton, Jones & Co., Taunton, was advertising daily runs (except Sunday) from Taunton to Lynmouth. Calling at both Dunster and Wellington Square en route, the service started on 8 July 1844. By the 1860s there was also the 'Prince of Wales' coach and journeys were to the Williton railway station and other destinations. Economic growth was beginning. Public meetings and auctions frequently took place in the hotel as well as lavish banquets for parties.

Adverts for 'surgeon dentist Mr Norman Washbourn calling at Westeria House, late Wellington Hotel' appear in local press throughout the 1879–81 period.

In 1878 a change of tenant saw a change of use. A craze for coffee houses led to the hotel becoming temperance hotel. As the Wellington Temperance Hotel in 1883 they were entertaining parties of the Church of England Temperance Society including outdoor events. Ironically the Ancient Order of Foresters met there for their regular court meetings but for their annual dinner met at the Plume of Feathers presumably so they could make toasts in the time-honoured fashion. The craze didn't last long and the hotel fell into disuse, but the then tenant thought a revamp to become

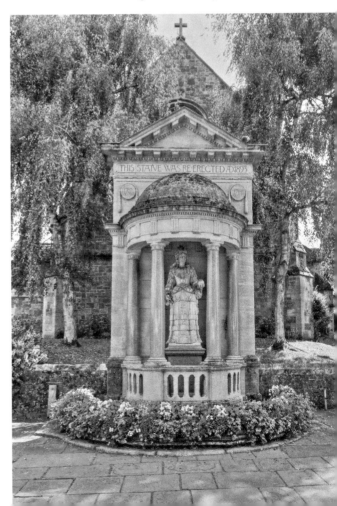

Queen Anne's statue presented to the town by Sir Jacob Bancks in 1719 and erected in Wellington Square in 1893.

a high-class temperance hotel may be just the thing, so in 1893 it was rebuilt and subsequently advertised to let on an annual lease. Regrettably it still didn't succeed, so under Walter Jennings tenancy in 1898 it reverted to selling alcohol much to the dismay of Mr Thristle of the Plume of Feathers. As Spirit and Wines Stores they sold local ales from Messrs Hancock & Son, Wiveliscombe Brewery. Now the hostelry is owned and run by the chain Wetherspoons, offering food, drink and coffee, and until the beginning of 2019 ran a nightclub upstairs.

The statue of Queen Anne was originally in the parish church but was removed in 1887 and lay derelict for several years before being re-erected in its current position. The original sculptor was Francis Bird (1667–1731), who is responsible for much of the work in St Paul's Cathedral. The covering dome is the work of architect Henry Dare Bryan and was constructed in 1894. Note the inscriptions, not just at the base of the original sculpture but around the dome also. When newly erected in Wellington Square there arose a dispute over who was going to pay to keep it clean.

Most town centres attract slightly unruly behaviour, usually encouraged by alcohol. Back in 1910 William Reginald Valentine Webb, associated with brewers Webbs (Aberbeeg) Ltd and one time tenant of Elgin Tower, was staying at the Wellington Hotel in the town centre. A display of decorated cars was being judged from the Plume of Feathers as part of a Guy Fawkes celebration. As the cars arrived in the square, Webb let off a firework out of the window, into the crowded square, which hit Thomas Besley, an insurance agent, in the eye, partially blinding him. Webb, who was also a former mayor of Torquay, said there were a few of them throwing the Roman Candles and he didn't know he had caused any injury until six months later. Bristol Assizes awarded Besley £600 damages for personal injuries caused by the negligence of Mr Webb.

West Street, Dunster

This is another of Dunster's ancient streets with a mix of both residential and business properties. It is thought that some of these buildings may date back to medieval times.

Chapel House, a former Methodist church and now tearoom and craft shop, was built in 1878 by Samuel Shewbrooks of Taunton. It was to replace a dilapidated chapel that was built in 1832 from semi-finished cottages and shops. The chapel closed in 1968 and by 1971 artist George R. Deakins (1911–82) was using it as a studio as pronounced by the plaque near the door. Deakins was a naval officer and began painting while on duty in the tropics. On retirement to Dunster he continued painting.

The Stag's Head Inn is believed to date to the fifteenth century. Originally a house, it was remodelled in the Victorian era. A few doors away is Stag's Head House, which it would seem was the original Stag's Head Inn while the current inn of the same name was the New Inn. The original Stag's Head seems to have attracted some long-serving landlords – Phillips, Thomas, Clarke to name a few – whilst the New Inn was under innkeepers Boon, Sparks and Long in the same time frame.

Above: West Street leading out of the village with a mix of business and residential properties.

Below: The Foresters' Arms, West Street, Dunster.

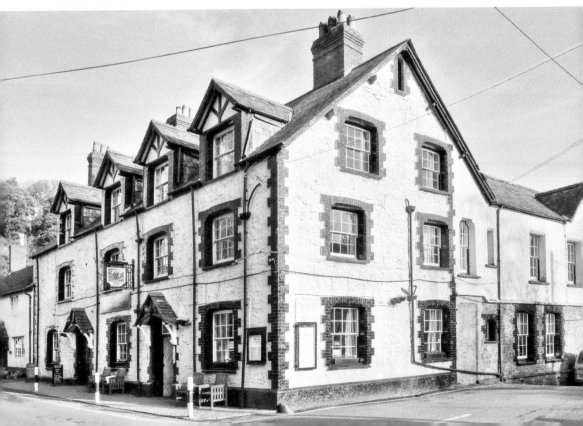

The Foresters' Arms, formerly known as The Bridge End Inn, is another old building that was remodelled during the nineteenth century. Originally licenced in 1849 by a tallow chandler, John Pitts, The Ancient Order of Foresters had their meetings in the inn – is this perhaps how its name was changed as one time landlord Mr Lettey was in office?

Grabbist House across the road was the former Cottage Hospital, which was run on subscriptions before merging with the Minehead hospital.

Wrecks

February 1648 saw a French ship 'bulgd in the sandes neer the keye at Mynhead', so Charles Staynings wrote to his kinsman John Willoughby. The goods of chestnuts and wine were removed over several days by the countrymen for fattening of the 'hoggs'.

In December 1847 a barque, *Frances Lawson* of Bridgwater en route from Quebec and laden with timber, came ashore during a gale, which continuing unabated threatened to wreck the stranded ship. Cutting their losses the wreckage was sold for cash later that same month.

October 1859 saw a storm so great that *Ceres*, lying at anchor off Watchet Harbour, was broken away from her chain and in the bad visibility the crew, thinking Warren Point was Minehead Quay, ended up grounded on the sand bank. One of the three crew bravely swam to shore to gain help from Mr Smith of Warren House and others, who rescued the remaining crew and two passengers.

On 19 January 1881 a Norwegian barque, the *American*, sailing from Gloucester to Baltimore laden with salt, foundered off Warren Point after a nearly disastrous happening. Earlier, the ship's carpenter Tallec Oslem, had not been rescued from the ship with his fellow crew as he had gone below deck. Finding himself alone he sailed the vessel to Blue Anchor Bay where he received 'attention' and then sailed on towards Minehead where the ship came to grief to the east of Warren Point.

Local shipowner Captain Pulsford lost his ship *Prosperous* en route from Minehead to Lydney in Gloucestershire. Storms in October 1891 and a series of misfortunes saw it wrecked and finally sunk, Captain Pulsford's third loss in a short time.

In 1898 *Dunvegan*, a barque carrying coal from Barrow to Capetown, was wrecked off Minehead lighthouse.

A survey by the government in 1856 ascertained that the lord of the manor – the Luttrell family – had the right of Wrecca Maris, which was the rights to the wreckage off the shore along much of this coastline. While being a shipowner could bring great prosperity, it could also bring about the downfall in a short space of time. At the mercy of the sea and the weather everything could change in a moment.

X

Xmas

Dunster by Candlelight is an event that was started in the 1980s as an attempt to keep the village 'alive' at the end of the tourist season and during Dunster Castle's closed period. It also raises money for St Margaret's Hospice in Taunton. Street entertainment, food and drink, shopping, fantastic lights and decorations make this an occasion high on the annual agenda and is held on the first Friday and Saturday of December.

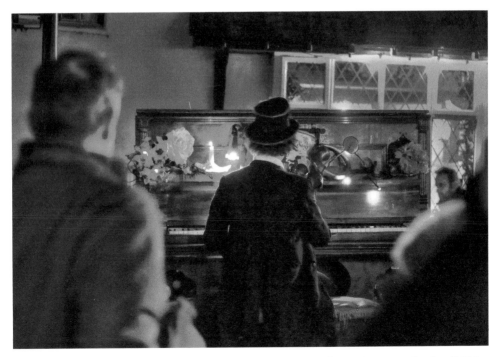

Rimski (Oliver Cumming) performing on his bicycle piano at the 2016 Dunster by Candlelight.

Yarn Market, Dunster

This is probably the most recognisable building in Dunster, situated in what is the middle of the street. It is octagonal in shape, dates back to the late sixteenth century and is an important indication of the cloth industry taking place in the town. It was extensively repaired in 1647 by the then current Luttrell following damage caused by the Parliamentarians, who seized the town a couple of years previously. The weather vane dates to the same year. If you look carefully at some of the wooden structure you can see initials in the sills created by hammered in nails. Also known as the Market Cross, make sure you look out for cannonball damage in the rafters.

Dunster Yarn Market at the top of High Street.

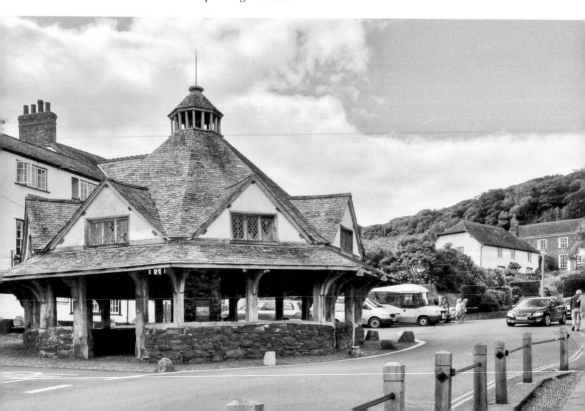

Z

Zig-Zag Path, Minehead

On North Hill a series of paths were created that form this zig-zag path through the trees. The climb up is steep and steady but plenty of seats along the way offer the walker resting places, with views between the trees to enjoy. One starting point to commence the uphill walk is between the cottages opposite the sculpture for the start of the South West Coastal Path.

Above: The start of the Zig-Zag Path as from Northfield Road and Church Path.

Right: The sculpture marking the start of the South West Coast Path, opposite the start of the Zig-Zag Path.

Bibliography

Binding, H., and Stevens, D., *Book of Minehead with Alcombe* (Tiverton: Halsgrove, 2000)

Collinson, John, *History and Antiquities of Somerset in 3 Volumes* (Bath, 1791)

Concannon, B., *History of Dunster Beach* (Monkspath Books, 1995)

Ditchfield, P. H., *Old English Customs etc.* (London: Methuen & Co., 1901)

Jones, Michael H., *Somerset's Unknown Painter* (Bridgewater: SCC Library Service, 1985)

Lamplugh, Lois, *Minehead and Dunster: A History* (Chichester: Phillimore, 1987)

Maxwell-Lyte, H., *Dunster and Its Lords 1066–1881* (Exeter, 1882)

Maxwell-Lyte, H., *A History of Dunster in 2 Volumes* (London: St Catherine Press, 1909)

Pevsner, Nikolaus, *Buildings of England: South and West Somerset* (Harmonsworth: Penguin Books Ltd, 1958)

Powell-Thomas, Andrew, *Somerset's Military Heritage* (Stroud: Amberley Publishing, 2018)

Savage, *History of Carhampton Hundred* (Bristol: William Strong, 1830)

Travis, John, *Smuggling on the Exmoor Coast 1680–1850* (Dulverton: The Exmoor Society, 2001)

Notes and Queries of Dorset and Somerset

Proceedings of the Somerset Archaeological and Natural History Society

Selected twentieth-century holiday brochures and guides

Church of St Andrew, Minehead (booklet)

Orbach, Julian (compiler), *Somerset Architects Index*

West Somerset Free Press newspaper

Websites:

Exmoor's Past: The Historic Environment Record for the National Park (Exmoor National Park)

Somerset Historic Environment Record (South West Heritage Trust)

Know Your Place – West of England/Somerset